IMAGES
of America

YUCAIPA

Thanks for Caring for Yucaipa

Harry Burklick

Judy Locke

J. M. Courtney W

Claire Marie Lutters

Marjorie Ford

Tom Ziech

Chas Terry

Henry Cole

Steve Maurer

David Sturdivant

Cecilia Johns

Lorraine Sturdivant

Sigrid Mortz

Anne Whitlock

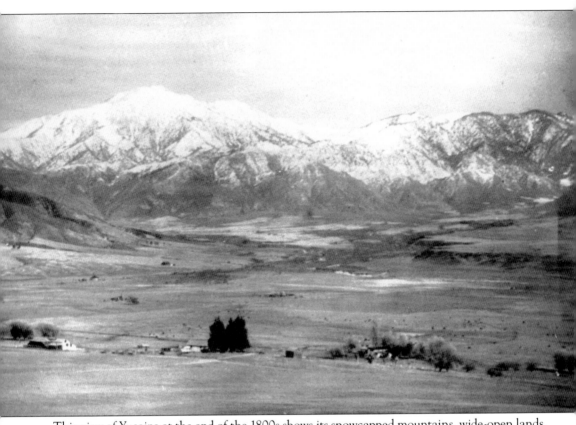

This view of Yucaipa at the end of the 1800s shows its snowcapped mountains, wide-open lands, the remnants of the village of Yu'kai'pat in the light areas, and the Yucaipa Adobe with the Dunlap family's ranch and dairy buildings in the foreground. A century later, the city of Yucaipa is a bedroom community with a continuing sense of hometown and family.

ON THE COVER: Yucaipa men and women pack peaches in the Yucaipa Farmers Cooperative facility, which was constructed in 1918. The peaches are being shipped under the Mountain Boy label, which was adopted in 1923. The image on the label is young Leon Atwood, son of Yucaipa developer George A. Atwood, owner of the renowned Casa Blanca ranch.

IMAGES
of America

YUCAIPA

Yucaipa Valley Historical Society

ARCADIA
PUBLISHING

Published by Arcadia Publishing
Charleston SC, Chicago IL, Portsmouth NH, San Francisco CA

Printed in the United States of America

Library of Congress Catalog Card Number: 2006938592

For all general information contact Arcadia Publishing at:
Telephone 843-853-2070
Fax 843-853-0044
E-mail sales@arcadiapublishing.com
For customer service and orders:
Toll-Free 1-888-313-2665

Visit us on the Internet at www.arcadiapublishing.com

This book is dedicated to Yucaipa's first peoples, the indigenous ones who enjoyed the bounty of this land. They built homes and left hundreds of stone artifacts that convey the information that this is a great place to live. We include in this dedication some other first peoples. In this case, the charter members of the Yucaipa Valley Historical Society, who led us to the path of preserving Yucaipa's history and heritage. Charter members include Morse Archer, Walt and Irene Miller, Ted and Betty Hunt, C. H. and Gertrude Hursey, Floyd and Mary Jane Setterfield, Nonie and Dovie McAnally, Edith Sherer, Esther Glaser, Alice Hammondt, Bob Stane, Dee Huckaby, Wayne Beers, Arylene Young, Marilyn Hunt, Carol Fehr, and Jessica Hunt.
We hope this book will make you proud.

CONTENTS

ACKNOWLEDGMENTS

The glory of working on Yucaipa's heritage at the Yucaipa Valley Historical Society is the accomplishment made by group effort, and this book is a prime example.

Photograph team leader Ann Whitlock took a hold of the gathering and sorting of the pictures along with Doug and Marilyn Draeger. Judy Locke, who has been processing the society's photographs for 14 years, delved into the archives and did the same.

Jack Curtright, who is a master cartographer, rifled through the map drawers and immediately began to blend modern data and early maps to provide perspective of early eras for which there are no known photographs.

Presidents Harry Birkbeck and Claire Marie Teeters began to organize the effort into eras, and after two months, the format for Images of America: *Yucaipa* took hold.

Tom Ziech, Steve Maurer, Dini Martz, Caecilia Johns, and Siegrid Martz went to work researching each photograph along with Whitlock and the rest of the team. Teeters fired up the computer and proceeded to produce the text. David Stirdivant, Marjorie Ford, and Birkbeck checked closely for accuracy. Each member of the society was invited to go through the notebooks to do the same, and many did. Char Lenz filled in at the computer.

Hank Cobb and Michael Gross engineered a new scanner into operation and each photograph began to take its place on a page. Ziech took over the new position of scanner jockey. Teeters detailed the page design and layout, and the book was finally accomplished.

For the photographs themselves, they belong to the community and were donated in order to preserve our history. We are deeply indebted to each photographer who captured Yucaipa over the years so Images of America: *Yucaipa* could share the essence of what makes the community such a wonderful place.

INTRODUCTION

For thousands of years, people have enjoyed the land that would become known as Yucaipa for good reason: it provides good water, rich plant and animal life, and resources for shelter. The climate is more moderate than the nearby desert and is perfect for year-round habitation. Stone artifacts are still being found of the first Yucaipans, and they include not only tools for providing food and shelter but gaming and ceremonial implements as well. Those people gathered at the village site called Yu'kai'pat, the origin of the community's name. The hearths, big house, and ceremonial sites have been rediscovered along the creek that—until 1875—flowed, providing the small lake and marshlands that once covered the lower areas of the community.

Representatives of San Gabriel Mission discovered that the water and vast grasslands were perfect for raising cattle, and this is one of the reasons the mission became so successful. After secularization in 1834, Ygnacio Palomares continued to raise cattle and horses on the fertile land. By 1839, Mexican colonists were granted the right to start settlements. Palomares applied for a land grant for the whole San Bernardino valley, including Yucaipa. Jose Antonio Pico had applied, too, in 1837. Neither of their applications was approved.

Juan Bandini discovered a desirable yellow metal near Crystal Springs and requested permission to mine the gold in 1839–1841. He sent samples of the ore to Mexico City for assessment.

Mexican governor Juan Bautista Alvarado granted part of Yucaipa in the San Bernardino Rancho to the Antonio Maria Lugo family in 1841. A nephew, Diego Sepulveda, built an adobe and made the Yucaipa community his home until the family sold the holdings in 1851 to Amasa Lyman and Charles Rich, members of the Mormon Church. It would be later in the decade that surveys would determine exactly what parts of Yucaipa were involved.

Ownership transferred in 1857 to James Waters, who expanded the land's use. He is believed to have loaded up the remaining Serrano residents at Yu'kai'pat onto wagons and have moved them to the Morongo area. That action gave him total use of the village site and the water resources. Residents found the land perfect for raising cows, horses, and hogs. Before long, loaded wagons rolled in, carrying people, furniture, and tools. Grain was planted, and dairies produced milk and cheese. The bounty of these efforts rolled out foodstuffs to Los Angeles and the mining areas of Arizona, giving the community the moniker "Breadbasket of Southern California." The Dunlap family purchased a major portion of the land and continued to expand their enterprises.

The earthquake of 1875 changed the flow of Yucaipa Creek, and, over the next century, the water table dropped, allowing the pioneers and 20th-century residents to construct homes and ranch buildings on the Lower Bench of the community.

Franklin Pierce Dunlap built a house in the eastern area in 1883, moving the center of town to his new house in upper Yucaipa. That home became a post office and was used as a hotel and center for society. The area was called Yucaipe, without the "a."

After educating children in a facility built on sleds so that it could be moved from place to place, Pass School was constructed nearby on Cherrycroft Drive and also served as a church and community center. The first time organized government was discussed was in the 1890s, and the

town, had it incorporated then, would have been called Dunlap. The Literary Society, in addition to school and holiday events, provided social gatherings.

Meanwhile, honey production was becoming another very successful endeavor, with thousands of gallons of honey shipped out by wagon to the Crafton train station. Early flumes became more sophisticated water tunnels, and irrigation systems began to provide for orchards and fruit industries.

Cherries were planted on the North Bench. (The community is a series of benches named Pine Bench, in Oak Glen; South Bench, today's Calimesa; Middle Bench, center of town; Lower Bench, Dunlap acres; and North Bench, the area east of Bryant Street and north of Oak Glen Road.) Cherrycroft Ranch became famous for its fruit and drew thousands each year to pick and/or purchase the Black Tartarians.

Toward the end of the century, land developers purchased many of the ranches; formed the Redlands-Yucaipa Land Company with 11,000 acres in central Yucaipa; and designed subdivisions. The new area was referred to as "The Townsite," and it opened a new era for Yucaipa.

The 20th century brought streets, homes, churches, businesses, and industry. Thousands of acres of land were planted into apple orchards. The community thrived, but after a few years, the climate was deemed to be too warm for apples, and in the 1930s, the trees were replaced with peach, plum, and walnut groves. These also proved to be lucrative. Agriculture continued through the Depression years.

New churches, new businesses, and new organizations joined in. Parades celebrated the good life of a rurally oriented community with a hometown centered at the upper end of Yucaipa Boulevard. After World War II, new businesses, especially poultry and rabbit raising, joined the orchard industry. Some sections of town, however, gave way to tracts of new homes. The beginning of Yucaipa's bedroom community style of life began.

While Yucaipa's greatest asset has always been the family owned-and-operated businesses, more and more residents found employment in nearby cities. The hometown entrepreneurs continued to work on community activities, and new parks and assistance programs were established to serve all Yucaipans, from the wealthy to the not so rich. The village atmosphere thrived, and children grew up in extended family neighborhoods.

While the residential areas continued to add new neighbors, it was not until after the water-treatment plant was in operation in 1986 that the massive construction brought new fast-food restaurants and that franchises began to replace home-operated businesses.

Three years later, after six attempts over the century, Yucaipa incorporated as the 21st city in the county of San Bernardino. In 2007, with a population of over 50,000, there are many new neighbors and a growing effort to keep "hometown" as Yucaipa's middle name, sandwiched in the motto "Valley of Vision."

One

PREHISTORIC–THE 1800s
THE FIRST YUCAIPANS

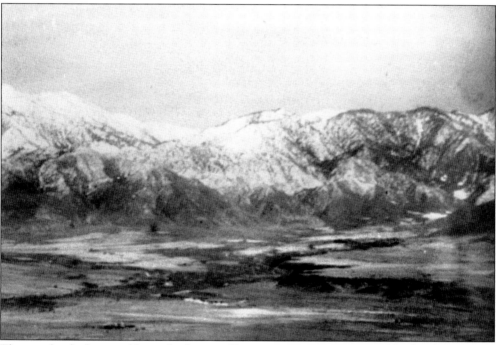

The grasslands that would one day become Yucaipa were a great source of food and water. It is believed the first peoples enhanced those assets by burning sections of the land in cycles to provide for their lifestyle. A village site, Yu'kai'pat, the light area in center-front of this photograph, was inhabited for hundreds of years next to a plentiful water source and covered much of the land around the Chicken Hill Springs area from the top of Greven Hill, south to Colorado Street, west to Thirteenth Street, and north to Yucaipa Boulevard. Hundreds of artifacts have been discovered at the village site and along upper Wilson Creek and in Oak Glen. The artifacts, primarily of stone, not only reflect the foods but also the interrelationships with other peoples. Yu'kai'pat was located along a traditional trail and is renowned as a meeting place of people and as a trade site. Baptismal records at San Gabriel Mission described people from Yu'kai'pat being baptized there in 1812. They also say that it was from Yucaipa that some of the mission-retribution actions were organized, including the attack on the Asistencia.

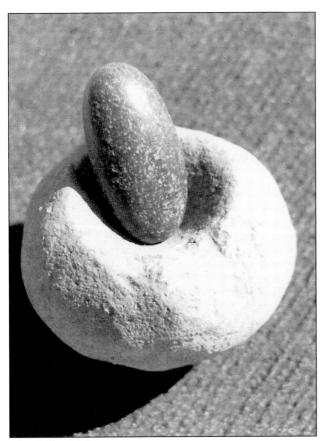

Literally hundreds of metates and mortars and pestles were left behind to be uncovered in the 20th century. Most were found in the village site, as was this tiny paint pot and pestle, but many, some thousands of years old, were found in high places such as Eleventh Street, Tennessee and Colorado Streets, and Live Oak Canyon Road. The North Bench also was rich in artifacts, being particularly close to the natural springs. Small mortars were used in ceremonies and large ones for food processing.

Many of the stone artifacts were decorated, as is the flower-shaped mortar on the right and the comale above the metate on the left. The comale's hole was used to lift the stone with a stick or pole in and out of a fire to heat. The stone was used as a cooking surface much like a frying pan.

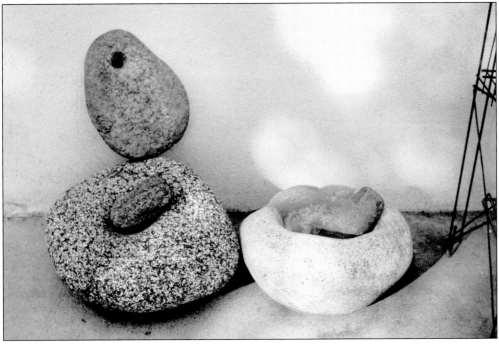

The Yucaipa Arrowhead is located on the south side of Pisgah Peak in Davies Canyon. It can be seen from the corner of California Street and Avenue H, and from some of the areas along Wildwood Canyon Road. The faces in the arrowhead change with the light of day. Big heads are referred to in one story from Native American predecessors. An ancient trail leads to a viewing point on a nearby hill across from the stone arrowhead.

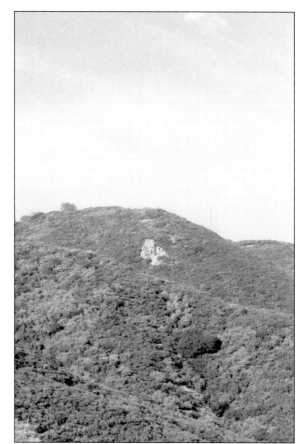

Several cog stones have been found in Yucaipa. Named for the notches on the round and elliptical stones, the artifacts' uses are unknown, but they are estimated to be thousands of years old. They also are only found in very few places in the world.

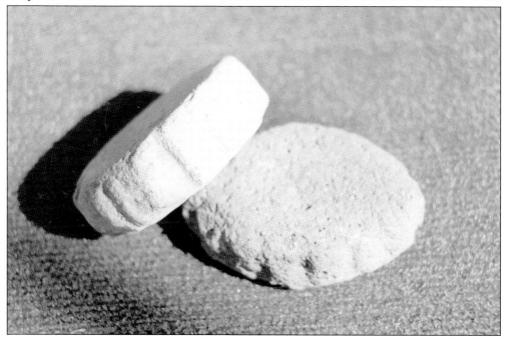

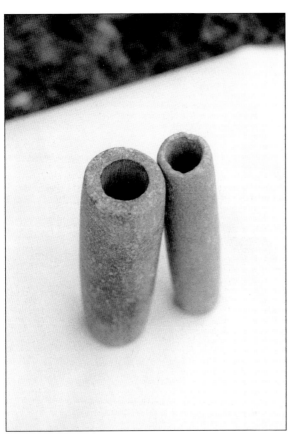

Ceremonial sites left clues to medicinal practices, puberty, and special rites. These stone tubes were medicinally used to remove disease and are rarely found.

These abalone shells are examples of imported goods. Thousands of shell beads have been found in the community, and none of them is indigenous. Most were carried from the Pacific Ocean. Yucaipa served as a trade center along ancient trails. Pottery shards from the Pueblo people have been found, along with the shells and stone from Mexico.

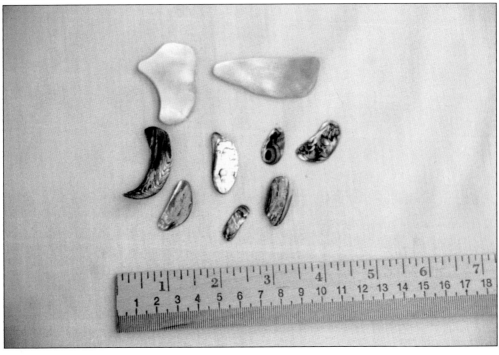

Yucaipa became an outpost of the San Gabriel Mission in the 1820s and was one of the reasons the mission was so financially successful. Hides from cattle raised in Yucaipa were rendered at the missions and shipped from San Pedro back east. After desecularization of the mission, Ygnacio Palomares and others continued to graze cattle and horses. Palomares intended to stay and applied for a land grant. A nearby adobe structure there is named after him. There is a reference to another adobe on the North Bench, but its remains have not been found. Juan Bandini, during that time in 1839, is credited with discovering the first gold in the community. Don Antonio Lugo received the grant for the Rancho San Bernardino, including a portion of Yucaipa, in 1842, after his family received rights to colonize the area. It was Diego Sepulveda, Lugo's nephew, who constructed an adobe dwelling in lower Yucaipa near today's Daniel's Market on Dunlap Boulevard. More recent data states that the structure was destroyed in a fire and parts of the adobe were used later to build the Yucaipa Adobe.

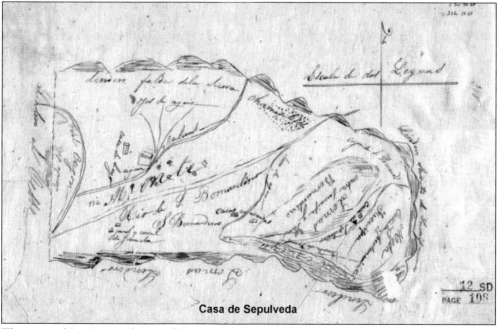

Casa de Sepulveda

This map of San Bernardino and Yucaipa in 1841 is from a traced copy of the original map, or "diseno," filed by Antonio Lugo with the application to the Mexican governor for a grant of the land. The following five dwellings are indicated: "Casa de Lugo" on the site of the current San Bernardino County Courthouse grounds; "Jacal Jumuba" for the former keepers of the mission cattle; "Casa arruninadas," mission rancho headquarters; and the Asistencia and "Casa de Sepulveda" in Yucaipa. Connecting roads are shown as dotted lines. "Saca de aqua" is the Mille Creek zanja. (Courtesy of the General Land Office, Washington, D.C.)

One of the local resources sought in the Mexican era was gold. Four Mexican-era mines and arrastra sites where ore was processed have been located in Yucaipa. This mine shows the entrance tunnel and shaft down to another section of the gold vein. Forty years later, miners would name it the Gold Bar Extension No. 2.

The shaft leading down to the mine below follows the gold vein in Gold Gulch. The mine was described in an 1889 newspaper article in the *Citrograph* named "A Trip to the Gold Bar."

The Lugo family sold much of the San Bernardino Rancho to two apostles of the Mormon Church in 1851. It was after the lands were surveyed in 1853, however, when it was determined that the sale included the rancho land in Yucaipa. The adobe is located in Block No. 79 of the rancho map.

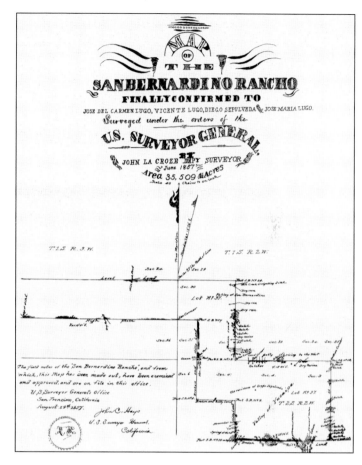

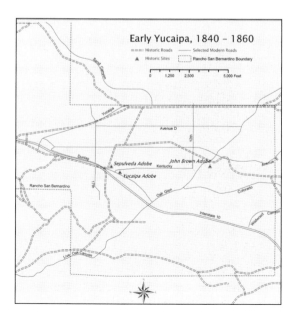

Early Yucaipa, 1840 – 1860

Even though the land was owned by the Mormons, John Brown Sr., a former Rocky Mountain trapper, moved to Yucaipa in 1853–1854 and resided there until 1856. During that time, he also built an adobe east of the remains of the Sepulveda adobe. He ran cattle up to Oak Glen in 1856, long before its pioneers settled into the area. Brown had disagreements with the Mormon people over his residency. In that year, his neighbors pleaded his case in a letter to Charles Rich stating that they believed the land to be public domain. He moved shortly thereafter to San Bernardino. He was a justice of the peace and performed the wedding ceremony for his longtime friend and another Rocky Mountain man, James W. Waters, to Louisa Margetson in 1856.

James Waters purchased the Yucaipa land holdings in 1857 and immediately began to capitalize on its resources. He ran cattle and swine up to Pine Bench in Oak Glen and introduced pigs to the eastern area of Yucaipa, where they fattened up on the acorns and berries. The area became known as Hog Canyon. He raised cattle, sheep, and horses on the land, as well as large quantities of honey. His 1867 tax assessment lists his property in Ucypa (Yucaipa) with a total value of over $26,000.

James Waters, in his efforts to capitalize on the resources in Yucaipa, is said to have moved the indigenous peoples from their village to the Morongo area.

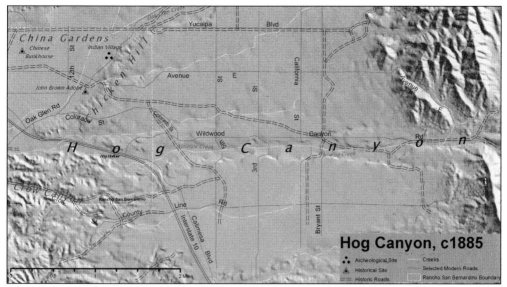

Early maps of Yucaipa designate the area from lower Yucaipa through upper Wildwood Canyon as Hog Canon with areas known as Hog Hollow. The names were changed by 20th-century developers Andrew Dike and John Logie, as Wildwood Canyon's name was "more euphonious."

Mark Whitesides settled into the area and operated the hog business. The ranch site, which is described on early maps as Hog Hollow, is still a heavily oaked area along today's Lime Kiln Road. The bacon and ham would be shipped in the 1860s to mines and populated areas through the southland. A son of Whitesides was one of the three killed in the San Bernardino Mountains in 1867, which set off the massacre of the Native American people of the mountains. Their descendents are today's San Manuel Band of Mission Indians. The Whitesides ranch was also known as the Guthrie place many years later. The road that was used to run the hogs up the meadow still exists.

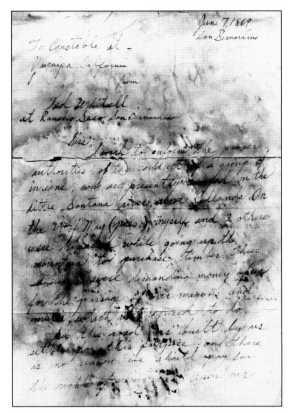

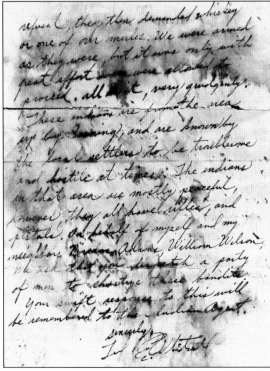

Law enforcement for the area was handled by a constable in Yucaipa during 1869. A letter of complaint and request for service was sent by Mentone area residents. It reads:

June 7, 1869, San Bernardino, To Constable at Yucaipa, California from Ted Whitsell at Rancho Seco, San Bernardino, Sirs: I wish to inform the proper authorities of the conduct of a group of Indians who are presently camped on the little Santana river, above Redlands. On the 17th of May, myself and two others were harassed while going up the mountain to purchase timber. These Indians were demanding money of us for the passage of our wagons and mules, which we refused to do. Sir, this road was built by us settlers for this purpose and there is no reason we should pay for the rights of using it. Upon our refusal, they then demanded whiskey or one of our mules. We were armed as they were, but it was only with great effort we were allowed to proceed, all be it, very grudgingly.

These Indians are from the area up by Banning, and are known by the local settlers to be troublesome and hostile at times. The Indians in that area are mostly peaceful; however, they all have rifles and pistols. On behalf of myself and my neighbors, Nicholas Adams, William Wilson, we ask that you dispatch a party of men to chastise these bandits. Your swift response to this will be remembered to the Indian agent.
　　　—Sincerely, Ted E. Whitsell

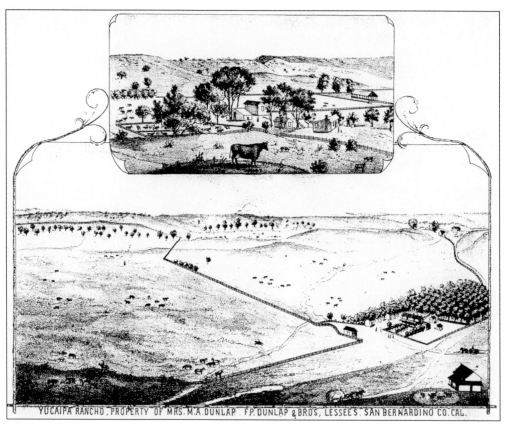

YUCAIPA RANCHO, PROPERTY OF MRS. M.A. DUNLAP. F.P. DUNLAP & BROS, LESSEES. SAN BERNARDINO CO. CAL.

John Dunlap, a Texas cattleman, and his partner William Riley Standifer purchased the Waters Adobe and the surrounding 3,840 acres of land on March 27, 1869. The deed refers to it as the Yukypa Rancho. Dunlap and his sons raised barley, cattle, and sheep and ran a dairy for over 40 years. It was the dairy and the farming, though, that made the Dunlap family name famous for the three generations who owned the ranch. After John Dunlap's death in 1875, his widow, Mary Ann, leased the property to her three sons, and Franklin Pierce Dunlap ran the dairy farm.

The Dunlap Ranch, including the Yucaipa Adobe and dairy buildings, can be seen in this photograph of Yucaipa, *c.* 1880.

19

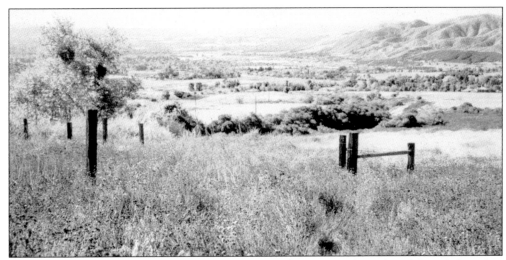

Early pioneers would stay at a spring in the northeast of Yucaipa, where the adobe is believed to have existed, while they chose a site to build their homes. The spring is on the Jackson Ranch overlooking the community. Local folklore tells the story of the Jacksons trading the land for a team of horses to the Mexican people who inhabited the area. Descendant Mildred Jackson was famous for sharing the water from the spring, as it is particularly good tasting.

Thomas Jonathan Wilson was a teacher, a chief-deputy tax assessor, and rancher in upper Yucaipa on the North Bench. On July 4, 1871, he married Isabel Rabel and made their home on a homestead on 480 acres on land first claimed by Joseph Webster. His home, located on the most easterly creek on the bench, included a library of standard works and a collection of mineral specimens and seashells. He raised stock, grain, and fruit trees. The road to his home is now called Carter Street, but the creek still bears his name. His ranch thrived, and Wilson was an important member of the community in the 1800s. By the later 1880s and 1890s, he was one of the leaders of the Literary Society, as he was known for his oratory abilities. In 1895, his family suffered a tragedy when his second son, Thomas J. Wilson Jr., died in an accidental shooting when hunting with George Birch, a 16-year-old friend.

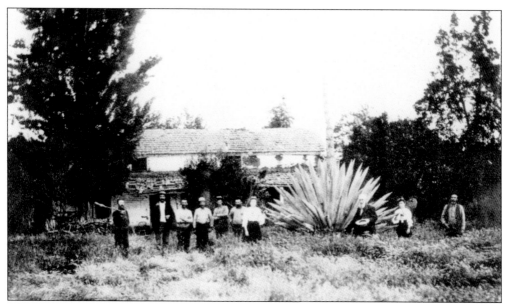

The Waters home is known today as the Yucaipa Adobe. This view was taken in the 1870s.

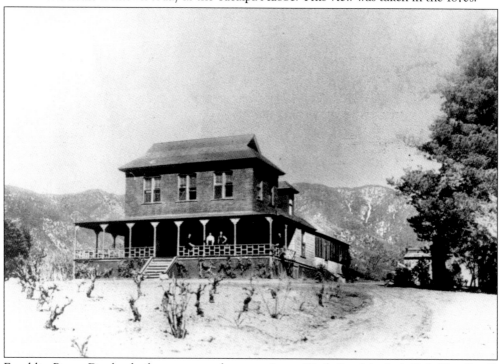

Franklin Pierce Dunlap built a two-story home on James Birch Road (today's Oak Glen Road) in 1882. It would be called Casa Blanca in later years. The site would become the center of local society, and the first incorporation effort—had it been successful—would have named the town Dunlap. The Dunlap ranch thrived. Casa Blanca became the local post office, where Yucaipans would ride up on horseback and pick up their mail through a window. Casa Blanca was considered as a possible stop along a proposed railroad line to pick up the huge amounts of grain and honey for markets back east.

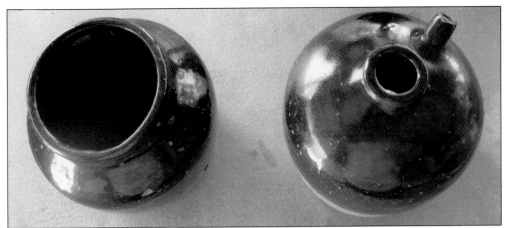

The Chinese bunkhouse was located on Thirteenth Street. Two Chinese jars are all that remain of the Chinese occupancy in Yucaipa.

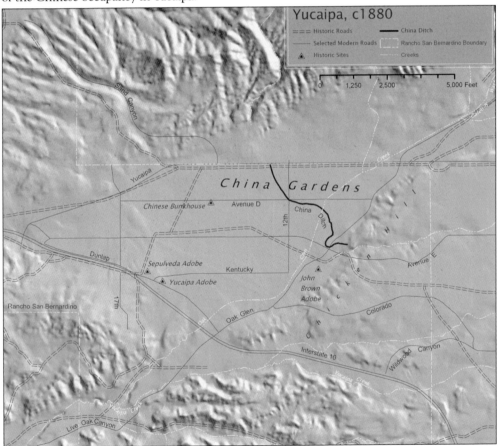

References to Chinese residents can first be found in an 1877 water record describing the China garden at the foot of Utah Street. In 1879, the Dunlap sons leased a tract of land that included the old Serrano village site to some Chinese to raise vegetables. They worked the Gold Gulch gold mines by day and their gardens by lantern light at night. They continued to thrive. In 1899, the lease to the Sun Sang Company rented 100 acres for four years for $1,300 a year.

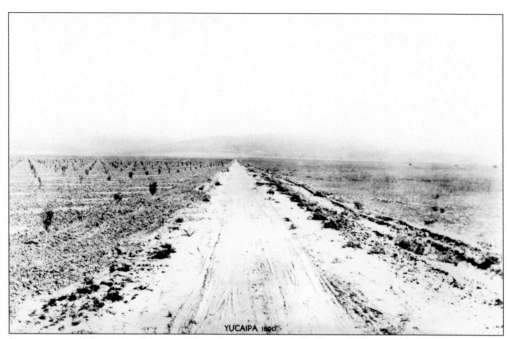

YUCAIPA 1890

It was not until 1893 that the South Bench, a portion of which would become known as Calimesa in 1923, ended up in the new Riverside County with County Line Road dividing the communities. This view of County Line shows orchards planted and Black Mountain at the end of the road.

On the North Bench, Domingo Matteis built a house from native field stone in 1890 near a natural spring and planted fruit orchards. His neighbor, Stephen Covington, planted 400 olive trees around the community as an experiment. Water tunnels were dug deep into the Yucaipa Ridge to provide irrigation.

23

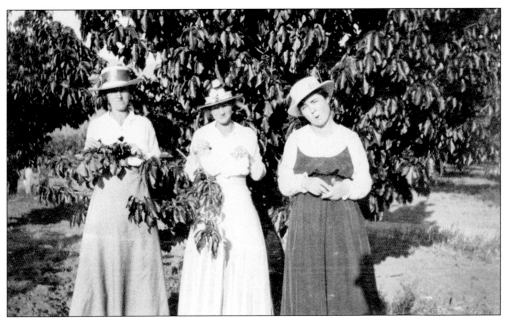

Three local young women exhibit and nibble on the area's famous cherries produced at Cherrycroft Ranch.

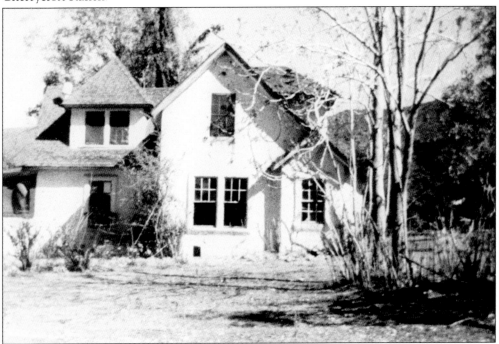

The Andrews brothers took the water development to a new level by developing irrigation systems using ceramic pipelines, cisterns, and weir boxes to provide for their Mount Carmel Fruit Company. They later became famous for their Cherrycroft orchards. The cherries were picked and hauled to the Crafton Railroad Station, to a cannery in Colton, or to market in Los Angeles. Well into the 20th century, the cherry industry drew large crowds to Yucaipa. This residence was the center of Cherrycroft Ranch.

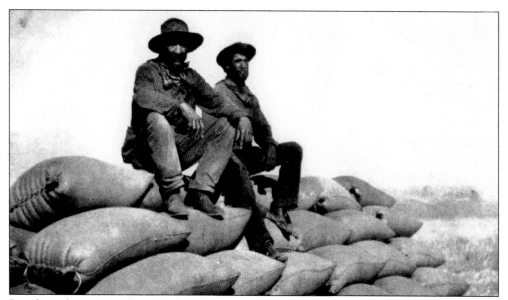

Ranch workers sit on the grain harvest they just sacked, which is ready for shipment. Yucaipa raised tons of grain each year, particularly in the 1880s and 1890s. Some of the barley was shipped east to breweries and some to Los Angeles markets. Many of the ranch hands worked the season; some show up on census data, and others are referred to in voter registers. (Courtesy of A. K. Smiley Library.)

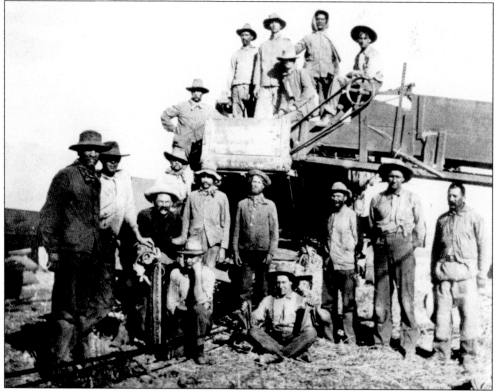

A harvesting crew gathers together after a hard day's work. (Courtesy of A. K. Smiley Library.)

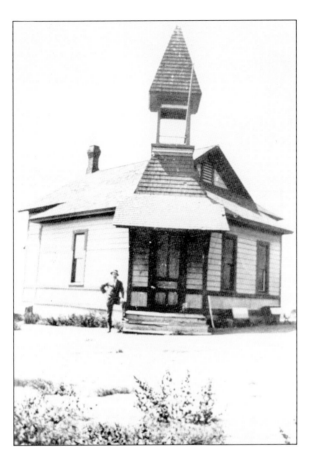

Yucaipa's first school was built in 1887 on Cherrycroft Drive. It was known as Pass School. Zella Wall Covington poses at the front steps.

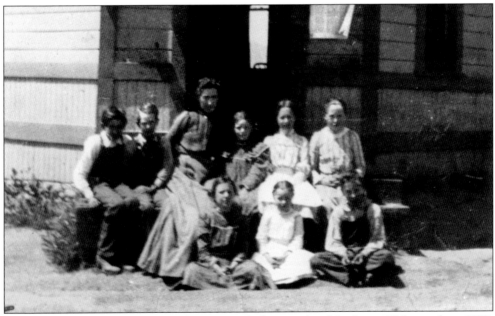

Students at Pass School gather on the steps with their teacher, Miss Lizzie Webster, about 1899.

Two

THE 20TH CENTURY
A NEW ERA

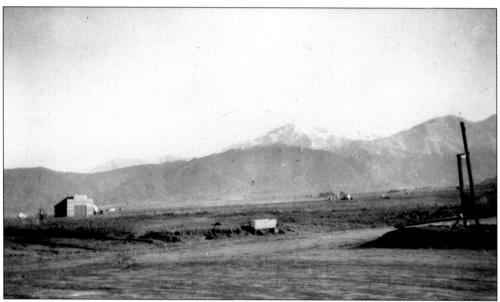

The first decade of the 20th century was quiet, as most ranchers had sold their holdings to the Redlands-Yucaipa Land Company, which was in the early stages of its subdivision plans. By 1904, the first apples were being planted in Yucaipa. This view shows the first blacksmith shop, open land, and Yucaipa Ridge in the distance.

La Miradora, constructed in 1902 by E. M. Boyd, is located across Oak Glen Road from Casa Blanca. The first floor included a kitchen, pantry, dining room, small breakfast nook, front room with fireplace that extended almost the full length of the house, a library, a big veranda, and a cellar, which still exists. The second floor held three bedrooms, a bath, and a long, screened bedroom porch. This view shows the rear of the home with Boyd's family, including the pet dog.

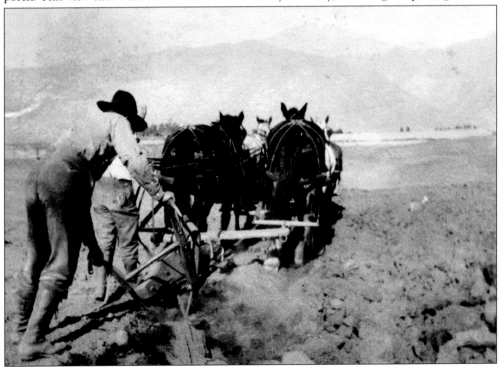

Early orchards were prepared the hard way—with plows and teams. Some orchards were planted as early as 1904.

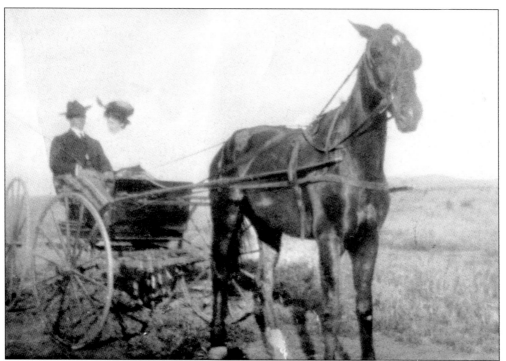

Roy and Caddie Cook travel across a field in the first decade of the 1900s. The Cooks owned extensive lands, operated a dairy in the Dunlap area, and were an important couple in Yucaipa society.

This view of Pendleton Road from the Pendleton house shows the North Bench area of cultivated land toward Casa Blanca and Oak Glen Road. The Pendleton barn is on the right.

Margaret Pendleton attended Pass School at Casa Blanca before the Yucaipa Grammar School was built on California Street. She is on Snow Ball.

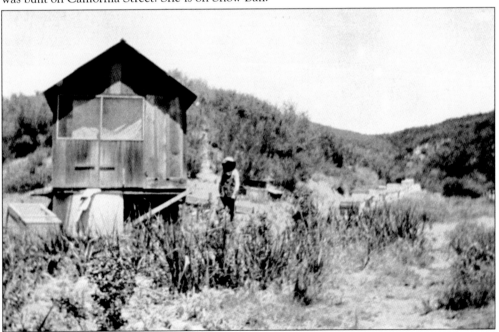

Beekeeping continued to be a good source of not only food, but income. Taken in the early 1900s, this photograph shows the hives and an outbuilding on upper Avenue E near the Norrbom home.

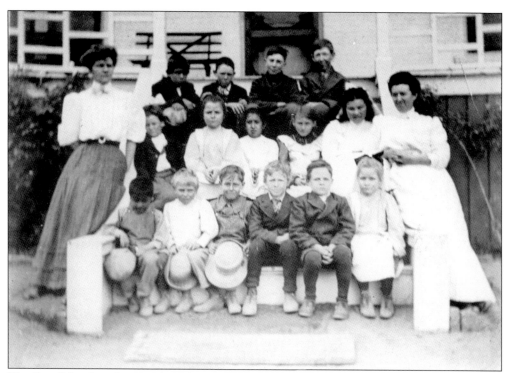
The Pass School students and teachers in 1908 are pictured in front of Casa Blanca.

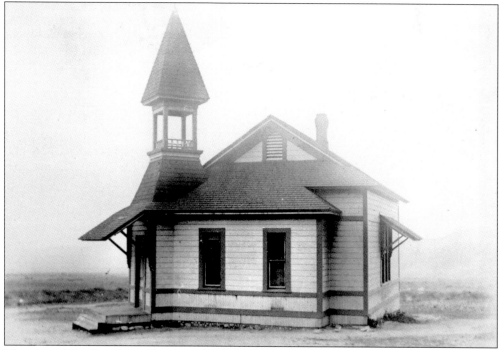
The view of the Pass School house in 1908 on Cherrycroft Drive shows the bare field around it. It would be many years before homes, other than the Atwood Ranch buildings, would be built near it.

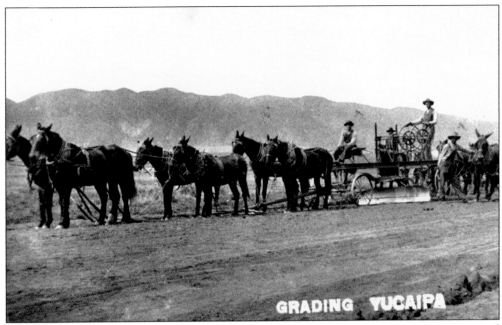

A local crew does some road grading in 1909. Cyrus Brandt is driving the mules. James and Perculle Barker Seams are running the grader link.

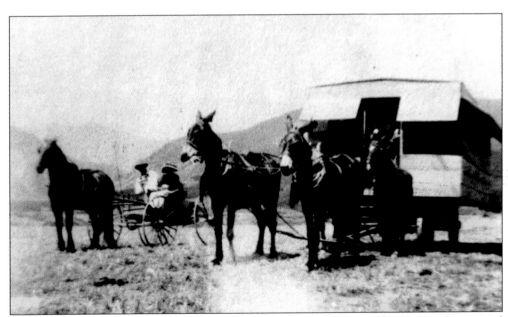

Eva Elizabeth Mohler Barker is in the buggy alongside the traveling cookhouse. Tent houses and wagon facilities provided shelter until homes were established.

Three

THE 1910s
LAND DEVELOPMENT

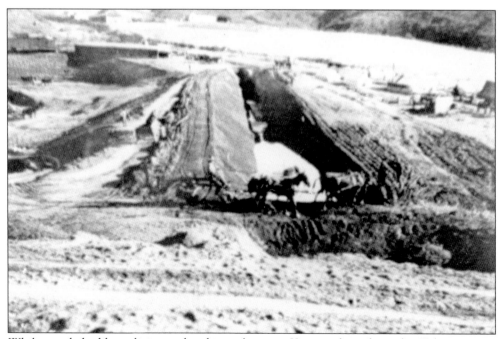

While people had been living and making a living in Yucaipa throughout the 19th century, a new level of development came with the construction of roads, water systems, and infrastructure, allowing organized subdivisions of homes and businesses. Manpower and resources were used to start the construction of the main dam of the Grandview Reservoir in December 1911.

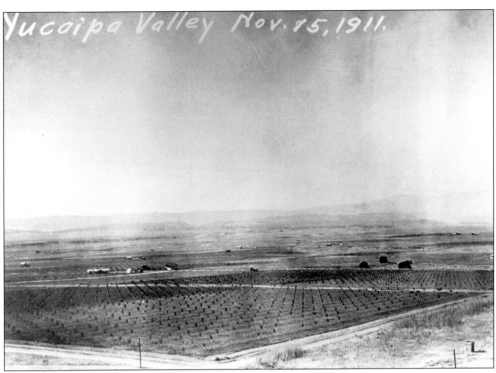

By 1911, vast areas of Yucaipa were planted with apples and more homes were under construction.

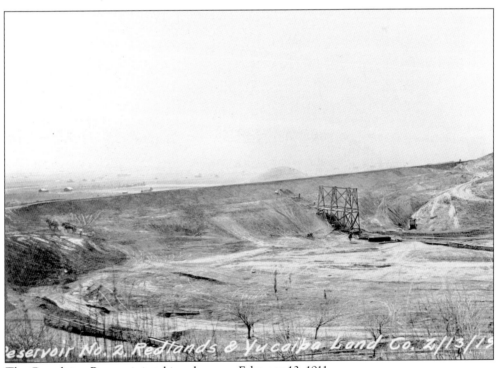

The Grandview Reservoir is taking shape on February 13, 1911.

34

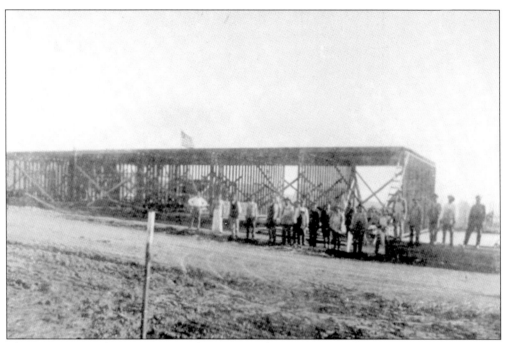

The Yucaipa Hotel was constructed in 1910 at the corner of today's Yucaipa Boulevard and California Street. The original structure was a two-story building. The first floor still exists.

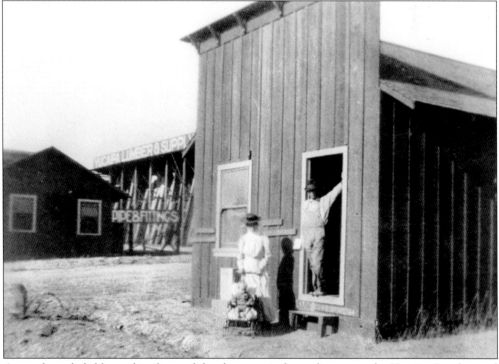

A couple and child stand in front of the shoe-repair shop adjacent to the Yucaipa Lumber and Supply yard some time between 1910 and 1915. The lumber business was very successful.

David and Lizzie Coey built a house in 1910 in Yucaipa at 12730 Fremont Street between Avenues E and F.

The Coey home in 1911 shows rock-lined retaining walls and edging popular during that era.

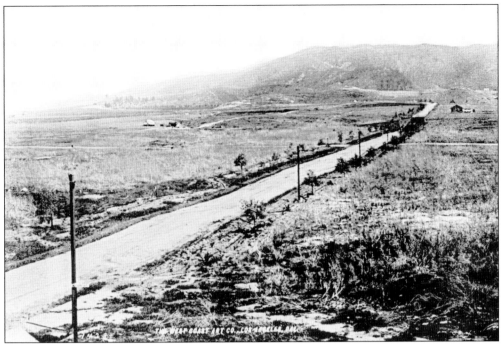

This view of Yucaipa Boulevard looking up to Flag Hill was taken from a window of the Yucaipa Hotel. The direction sign at the corner reads Yucaipa Avenue, the original name for California Street. A tent house can be seen to the left of the road.

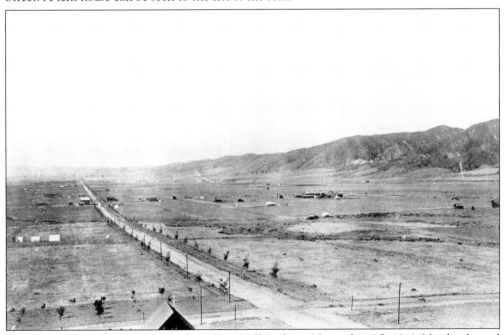

Yucaipa Boulevard extends west from Flag Hill Park on November 15, 1911. Newly planted eucalyptus trees were placed the length of the road. The cross street is Douglas. The Yucaipa Hotel can be seen down the boulevard on the left, and tent houses can be seen on both sides. Scars of 1880–1890 gold mining can be seen in the distance on the Crafton Hills.

George Pendleton stands in his apple orchard in 1912.

The road to the Pendleton Ranch went around the back of the home to the porch where everyone entered the home. This 1912 photograph shows the neat line of metal tubs and two women.

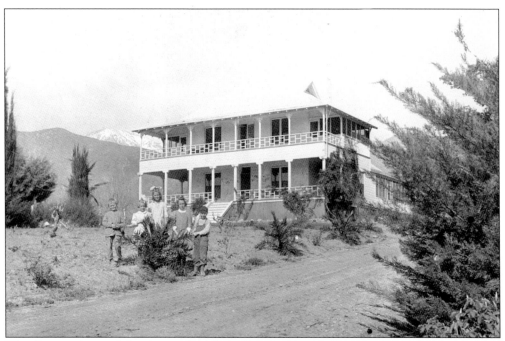

The George Atwood family purchased the Dunlap Ranch, and the house became known as Casa Blanca. One of the children standing in front of Casa Blanca in 1912 is Margaret Pendleton-Cunningham.

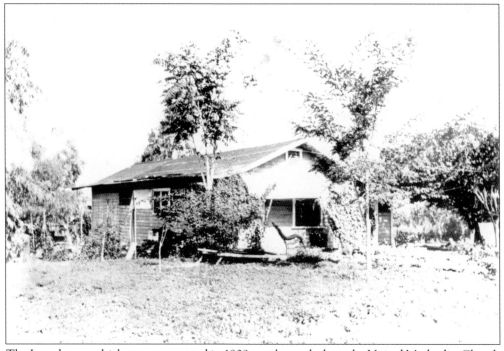

The Lane home, which was constructed in 1909, was located where the United Methodist Church of Yucaipa is located. Josiah W. Lane was an early manager of the Yucaipa Hotel.

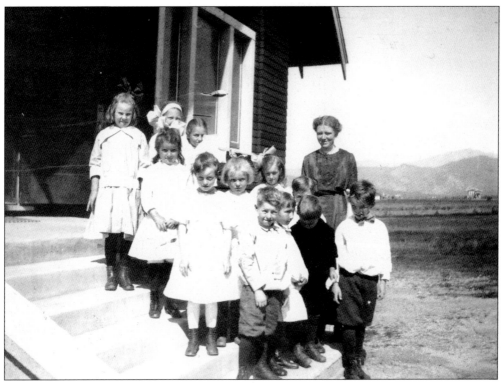

A Yucaipa Congregational Church Sunday School class stands for a photograph on the steps of the church in 1912.

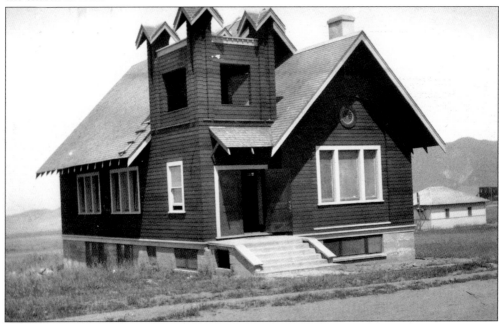

Religious services were held at the Pass School for 20 years. Yucaipa's first church, the Yucaipa Congregational Church, was constructed in 1912 at the corner of Avenue A and Adams Street. It was later moved to Avenue J.

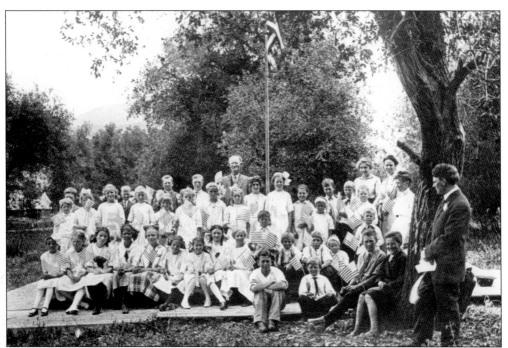

The Congregational Church's Sunday school class gathered in 1913 on July 4 in Wildwood Canyon. Pictured in no particular order are Haley Adams; the Bacon children; Elmer and Pauline Bise; Ollie, Esther, Edwin, and George Swanson; Sam Pope and his brother; the Miller children; Helen and Mabel Coey; Annie Hilton; Margaret Pendleton; Dean and Katherine Hudson; Edith Seeley and her sister; Marjorie and Elizabeth Parry; Reverend Sampson; and David and Lizzie Coey.

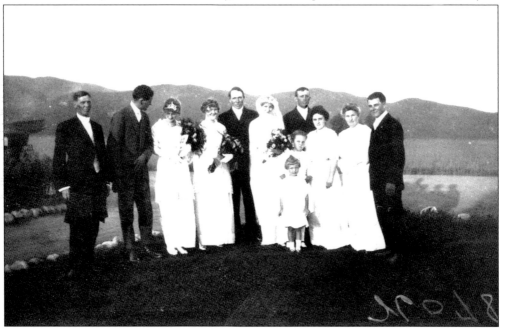

The George Matthews and Mabel Coey wedding party gathers on August 12, 1914. It was the first wedding held in the Yucaipa Congregational Church.

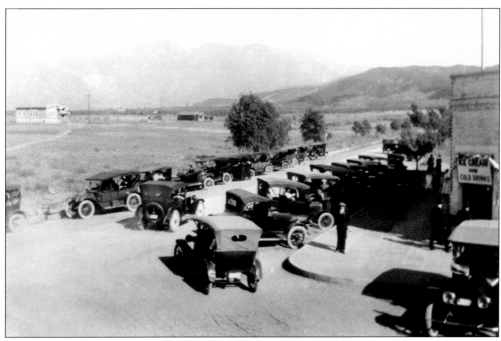

The cars parked at the corner of Yucaipa Boulevard and California Street were owned by shoppers. The Methodist church is in the background on Fifth Street and Montana Street, now known as Acacia and Adams Streets.

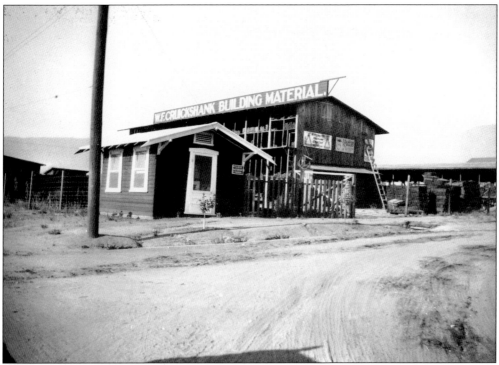

Cruickshank's building materials were in high demand as new homes, barns, and businesses were constructed. The Cruickshank family lived in the community for two generations.

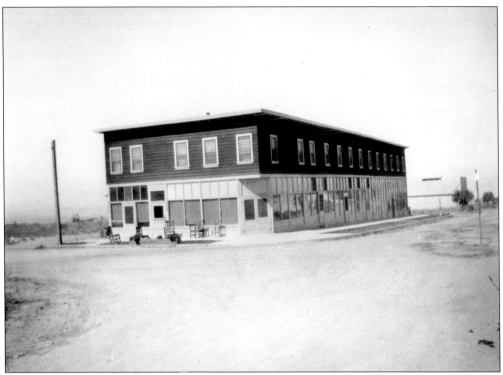

The Yucaipa Hotel and Tavern, c. 1912, dominates the corner of Yucaipa Boulevard and California Street. The door second to the left is still in use in the remains of the building in 2007. The cold-storage building can be seen down the boulevard behind the hotel.

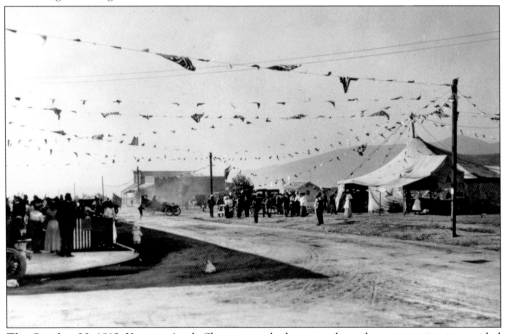

The October 30, 1912, Yucaipa Apple Show not only drew people to the community, it provided fun for the new residents.

Yucaipa's first mercantile store was built in 1909. Pictured here the following year, Mr. Logie is beside the car, Dan Dolen is by the door, and George A. Atwood is on the right.

The Andrews brothers' Cherrycroft fruit crop drew thousands of people to Yucaipa well into the 20th century. In 1913, many came in motor cars.

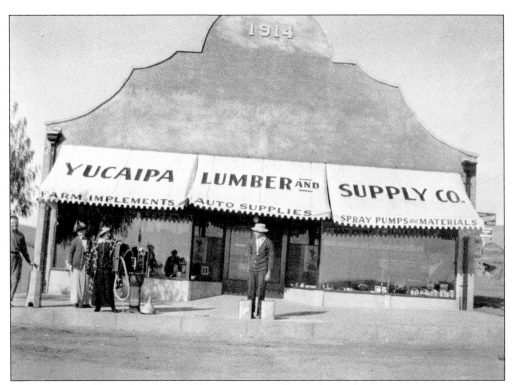

Unknown people stand in front of the Yucaipa Lumber and Supply Company store on Yucaipa Boulevard in 1914. The structure still exists today.

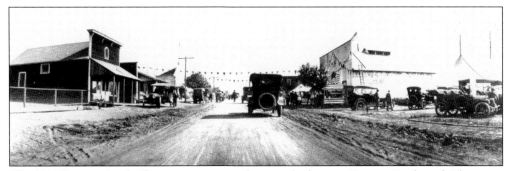

The 1912 Yucaipa Apple Show is in action in this view looking up Yucaipa Boulevard. The event was held next to the cold-storage building, on the right, to celebrate its construction.

The Yucaipa Woman's Club's cafeteria banner can be seen in this view of the 1913 Yucaipa Apple Show. The local women sold dinners to gather funds to open a library, which they were able to do in later years.

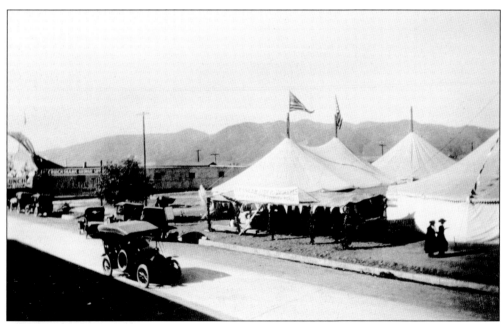

Yucaipa pride was evident in this apple display at the 1913 Yucaipa Apple Fair. The fairs continued until the Depression. Peach Festivals followed the apple era. (Courtesy of A. K. Smiley Library.)

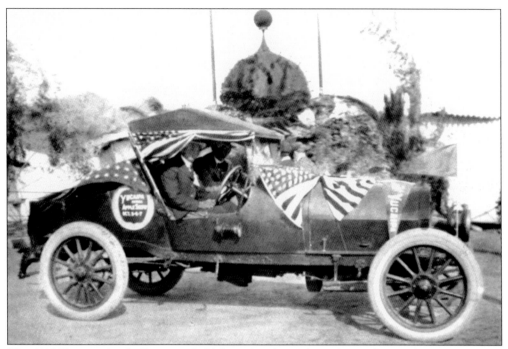

The 1913 Yucaipa Apple Show was held from October 5 through October 7. The car advertised the event. Notice the logo and the Yucaipa banner on the automobile. (Courtesy of A.K. Smiley Library; glass-lantern slide collection.)

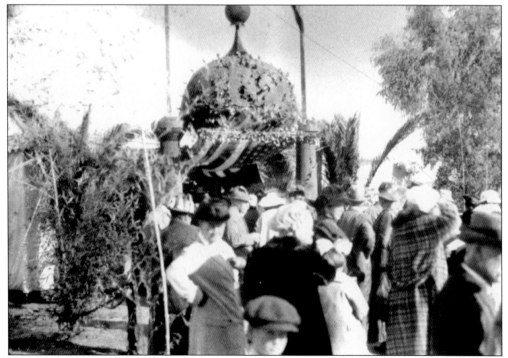

Visitors stand before the entrance gate to the 1913 Yucaipa Apple Show. (Courtesy of A.K. Smiley Library; glass-lantern slide collection.)

The furnishings inside George and Mabel Matthews's first home on Third Street and Yucaipa Boulevard are pictured complete with china, carpets, and lamps.

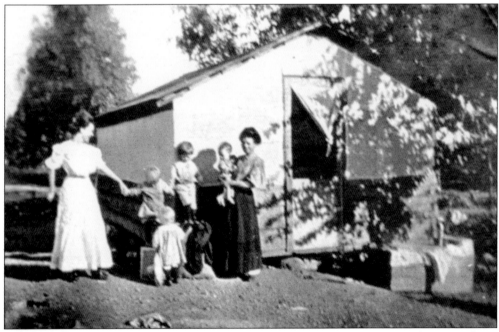

Families often lived in tent houses while their homes were being constructed. Pictured is a neighborly visit to one of the early homes.

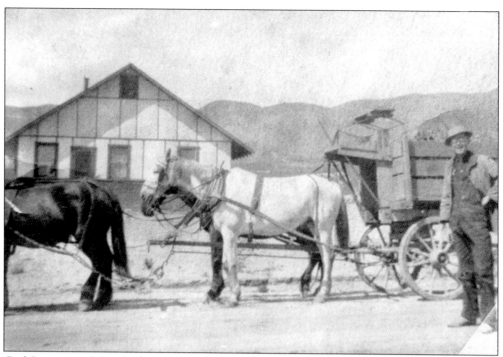

Carl Seams stands beside the wagonload of wood from Oak Glen in front of the Cobban home.

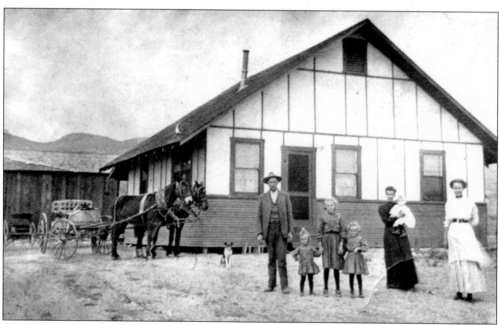

The Cobban family members stand in front of their Yucaipa Boulevard home. Pictured from left to right are William, Pauline, Lena, Nellie, Vida, Kenneth, and Lorraine, who was later known as Lorraine Priebe.

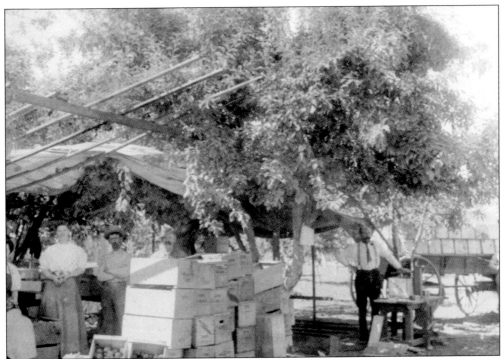

Apple packers work under a shed about 1913. (Courtesy of A. K. Smiley Library; glass-lantern slide collection.)

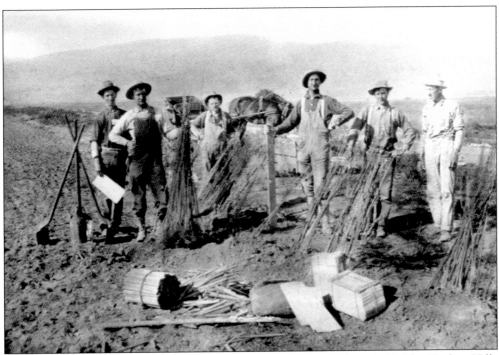

Local workers are ready to plant bare-root apple trees in Yucaipa about 1913. The Crafton Hills can be seen in the distance. (Courtesy of A.K. Smiley Library; glass-lantern slide collection.)

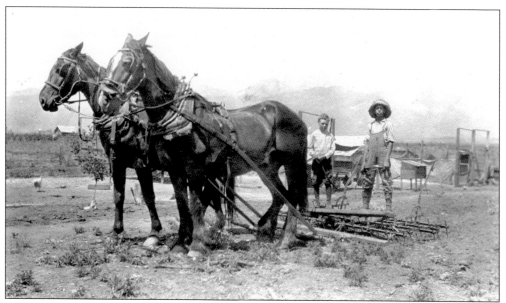

Will and Cyril Stoneham work on the Stoneham Ranch at Fourth and Cedar Streets on July 13, 1913.

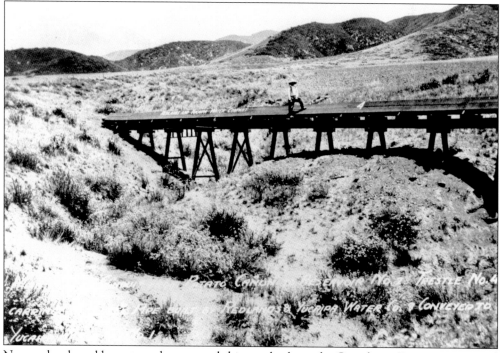

New orchards and homes need water, and this trestle above the Grandview Reservoir conveyed water. The trestle was built by the Redlands-Yucaipa Land Company.

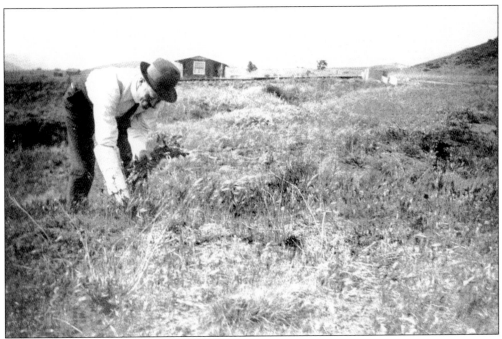

John Norrbom Sr. picks wildflowers in 1912 on his 14 acres at Fremont Street and Avenue E.

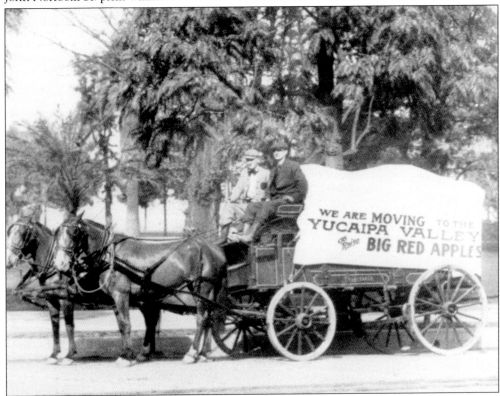

The Redlands-Yucaipa Land Company advertised via a wagon and banner. Wagonloads of people headed up the hill to the new Yucaipa townsite.

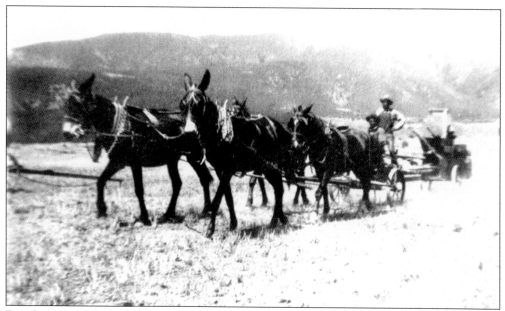

Ranchers move the hay baler in 1912.

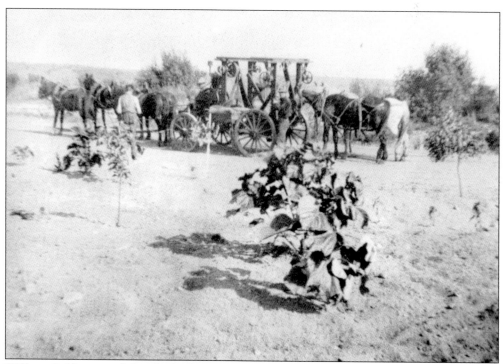

William Cobban stands beside the horse-clipping machine.

One of the students at the Yucaipa Grammar School in 1913 is Esther Swanson. Children from Calimesa, which at that time was part of Yucaipa, also attended.

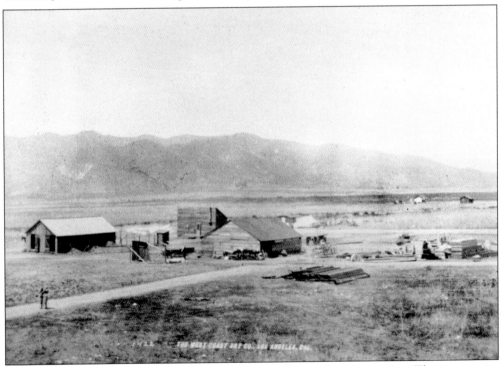

This early Yucaipa homestead, pictured here about 1914, is under construction. The community still shows wide-open spaces.

A man only identified as "D. G. M." was the bookkeeper for the Cope Ranch on the North Bench. He started keeping the records for Cope in 1902 and had the reputation of having a cigar in each hand a pipe in his mouth at all times. The photograph is *c.* 1915.

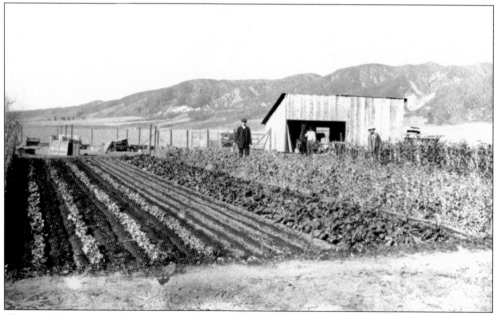

This *c.* 1915 photograph of a vegetable farm shows the growers, furrows, shed, and the Crafton Hills in the background.

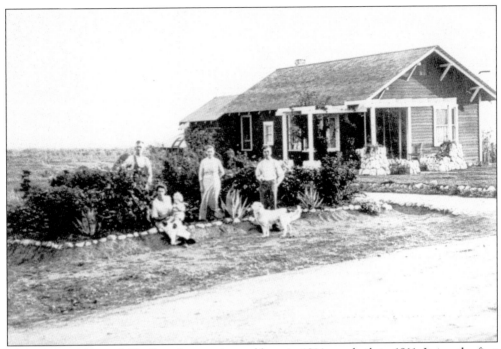

The John and Hannah Englbom home, pictured here in 1914, was built in 1911. It was the first home built on Avenue A between Second and Third Streets.

The Englbom home expanded into a fully operating apple orchard over its first decade.

Helen Coey Logan taught second grade at Yucaipa Grammar School for three years before going into the Red Cross during World War I. At home, local women, including Margaret Hudson, Lena Longwell, and Cora Southworth, coordinated the weekly meetings in the basement of the Congregational church, where muslin garments were sewn, socks made, and bandages cut and rolled. The Woman's Club raised funds for the Red Cross. During World War I, Yucaipa organized a Home Guard with Philip Hasbrouck as captain. Drafted in July 1917 were Ernest Richardson, Juan Ramos, Ernest Sutter, Quan Svon, Frederick Espe, Herbert Marsch, Fred Creason, Thomas Pitts, Lee Turner, Loren Paris, Walter Haws, Manuel Roberts, John Hundley, William Emmick, Jake Brakebill, William Weick, and Alexander Teague.

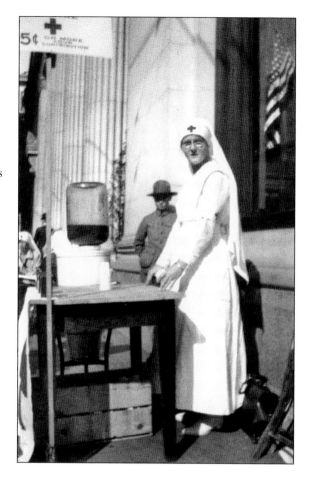

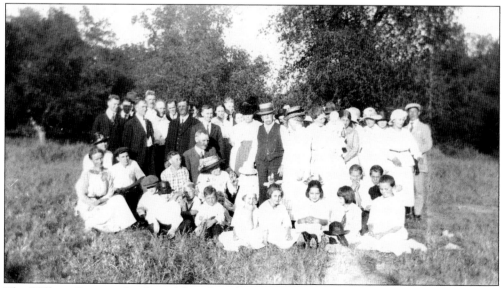

The William Peterson family and friends gather at a party in Wildwood around 1917.

A class at Yucaipa Grammar School is pictured here about 1919. After graduating from the eighth grade, students would be bused during this era to Redlands for high school.

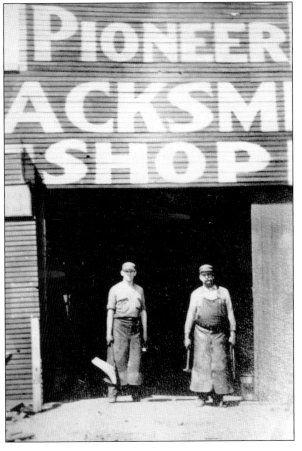

Garfield Quimby, left, and Sam Edwards stand in 1919 at Edwards Pioneer Blacksmith Shop, which kept local farmers' horses in shoes.

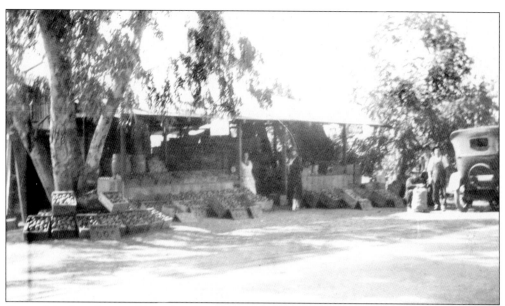

George Matthews's vegetable and apple stand was on the south side of Yucaipa Boulevard between Third and Fourth Streets.

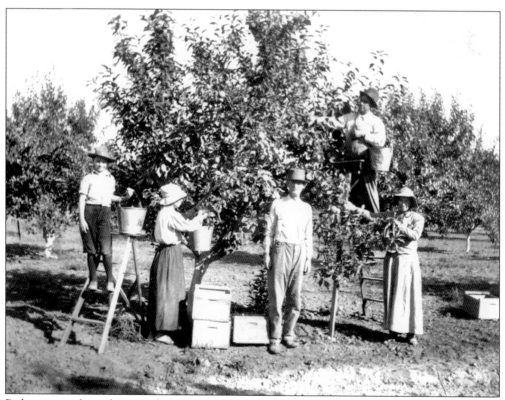

Pickers pause for a photograph during apple season in the Matthews orchard.

Looking west down Yucaipa Boulevard, workers are grading Katzung Hill. The hill was named after Charles Katzung, who had a home nearby at Seventh Street.

Road grading was a continuous process in the early century. Pictured in 1918 is a crew preparing to grade Katzung Hill.

Four

1920s
YUCAIPA BLOSSOMS

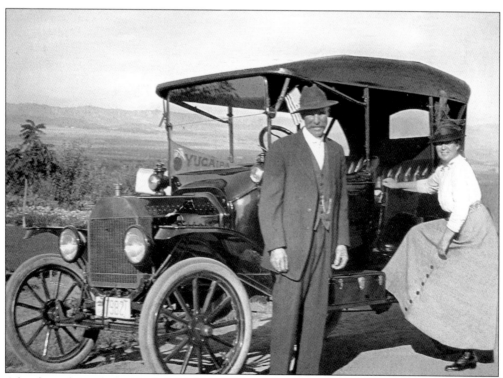

A local couple pauses beside their Ford Model T complete with a Yucaipa banner on the dashboard. The banner can be seen in several early photographs of Yucaipa, particularly during the Yucaipa Apple Shows. It was green, with dark green piping and a red apple.

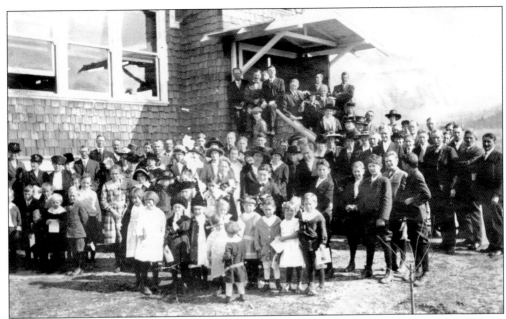

United Methodist Church of Yucaipa members gather on the church steps in February 1920.

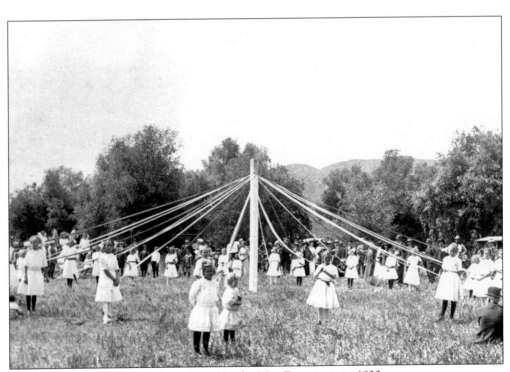

Wildwood Canyon was a traditional site for the May Day picnic in 1920.

Pictured from left to right, Gordon Lindsay, Cy Stoneham, and Larry Stoneham work with a team on the Stoneham Ranch at Fourth and Cedar Streets. The orchards were well developed and productive that year.

Larry Stoneham, Gordon Lindsay, and Vernon Lindsay cool off in a weir box in the Stoneham orchard.

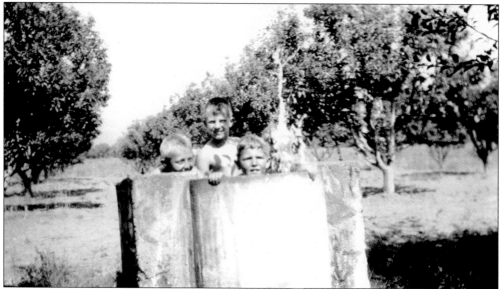

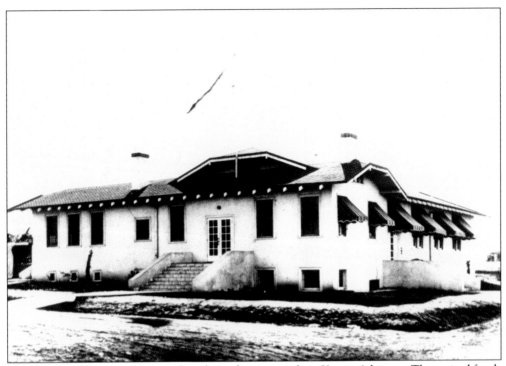

The women of the community gathered together very early in Yucaipa's history. They raised funds for the first library and for social needs through chicken and turkey dinner sales at the annual Apple Shows. In 1921, they had the Yucaipa Woman's clubhouse built at the corner of Adams Street and Avenue A.

This photograph of Yucaipa Boulevard at Tennessee Street was taken June 10, 1923, looking east through Dunlap toward the main part of town.

In May 1923, three hundred acres of the Clyde Ranch west of Bryant Street were leased for oil drilling.

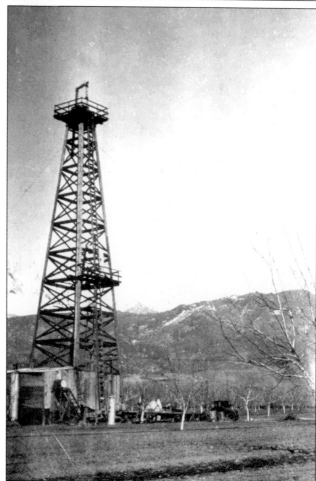

The Jimmy Gray "wildcat" oil rig had problems and was closed down. The drill, which became lodged in the ground, is still there under the El Dorado Palms Estates on Fir Avenue west of Bryant Street.

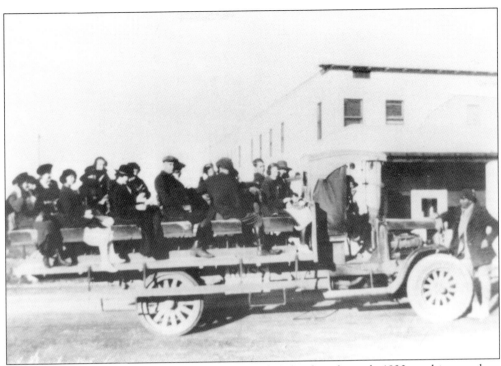

Dad Hansen drove local students to Redlands High School in the early 1920s on his open bus, which, in this photograph, is parked at the corner of Yucaipa Boulevard and California Street in front of the Yucaipa Hotel. The students were gathered at the Dunham store; some were driven by pony cart. The second year the bus traveled up County Line Road.

L. M. Zingery was the mail carrier in May 1923 in the Redlands-to-Yucaipa route.

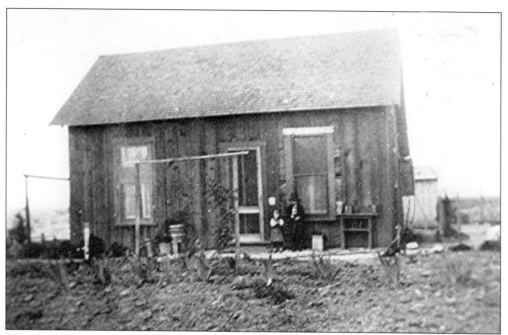

The Floyd White house was originally built in 1921 on Avenue F at Sixth Street. It burned down and was rebuilt on the same site. The family planted peaches and grapes on the property. Pictured are Ruth White Surber and Marie White Barnett. The family moved in 1927.

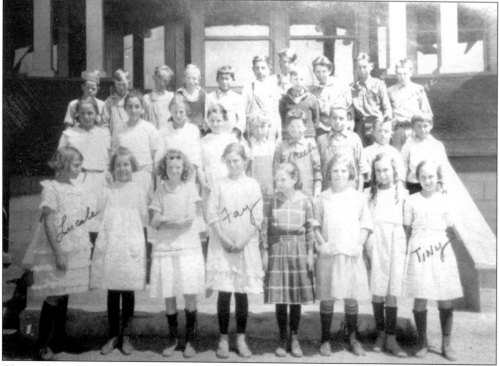

The sixth-grade class stands on the steps of the Yucaipa Grammar School in May 1922.

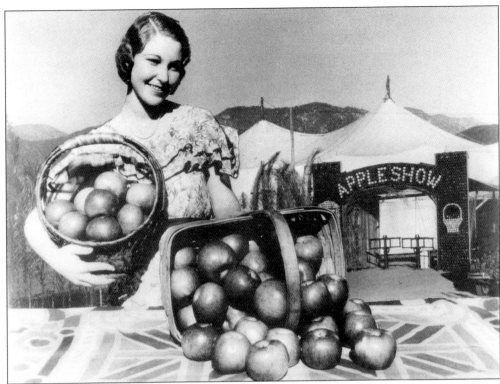

By 1925, the Yucaipa Apple Shows were being organized by the Yucaipa Woman's Club and were held adjacent to its Avenue A property. The front gate to the show was composed of apples. The shows continued to draw people from Los Angeles and the southland.

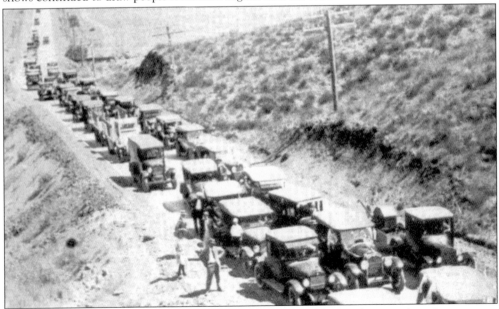

A new road from Redlands up Reservoir Canyon near Crystal Springs became the primary access to Yucaipa in 1925. Ocean-to-Ocean Highway opened with Road-Day-O celebration in 1925. It was also known as Highway 99.

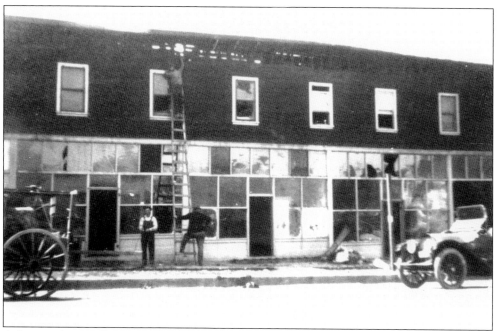

A fire on the top floor of the Yucaipa Hotel did heavy damage to the structure in 1926. The second floor was eventually removed. The bottom floor exists today as small businesses along the boulevard.

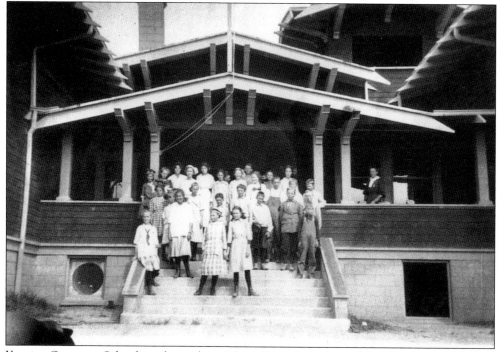

Yucaipa Grammar School was located on Adams Street facing west. The basement rooms were used for shop classes and the cafeteria.

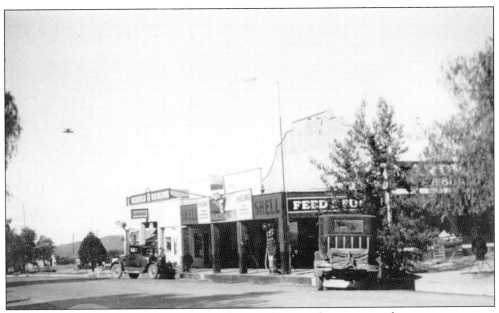

Uptown Yucaipa, pictured here about 1927, shows a change in businesses in the commerce area.

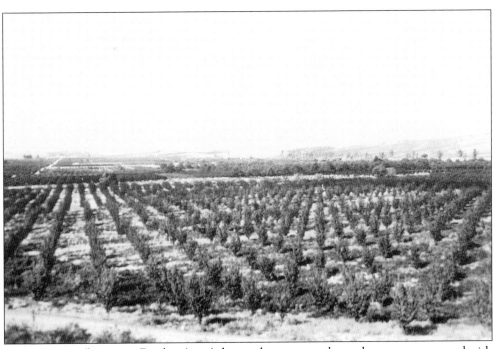

Lower Yucaipa (known as Dunlap Acres) during the same era shows the vast area covered with fruit trees in family owned orchards.

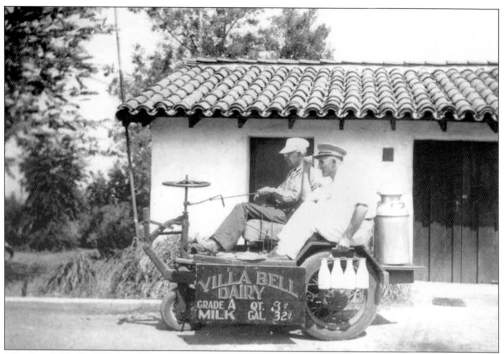

The first Villa Bell Dairy delivery truck had a retail route of 125 miles. Delivery started at 2 a.m. and ran seven days a week. The dairy was on Third Street and was built of adobe by Vida Bell. Note the milk prices.

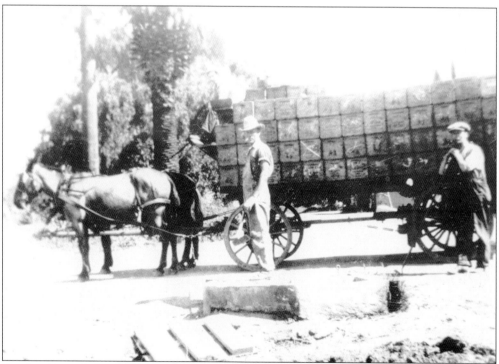

Gordon Greenslade is on the wagon on the Lyons Ranch during the winter of 1927–1928.

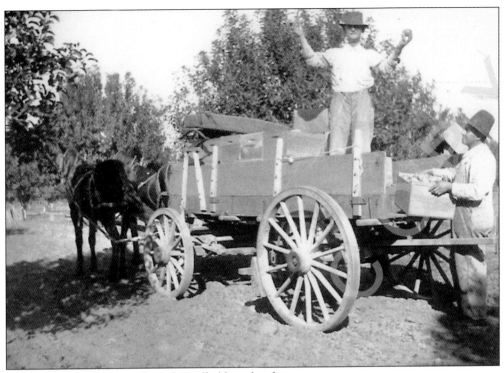

Two men load a wagon with apples pulled by a four-horse team.

A young Yucaipan heads out on his family's farm during the late 1920s.

Five

THE 1930s
MAKING IT THROUGH LEAN TIMES

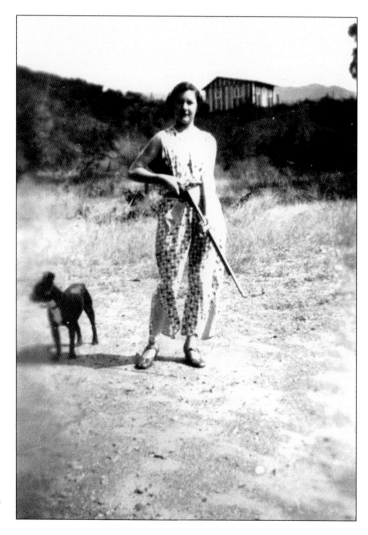

Marian Sweets and her dog Jiggs are off on a hunt near her home in 1930 in Wildwood Canyon. Many Yucaipans lived off the land during the hard years of the Depression.

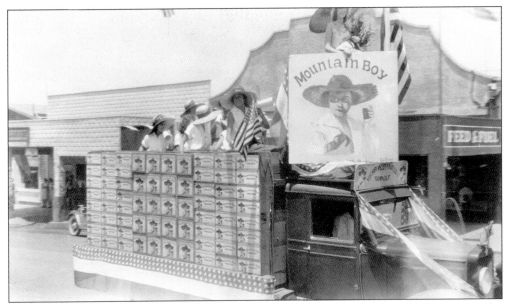

Yucaipa's Mountain Boy label is proudly put on display as the 1931 parade drives past the hardware store.

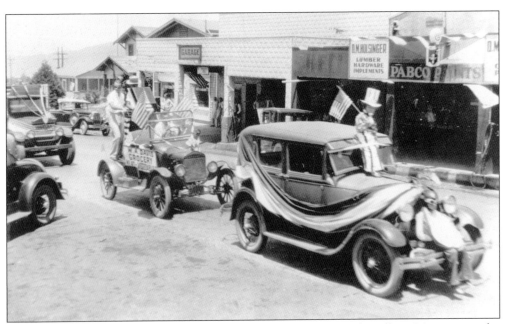

The 1931 Yucaipa Patriotic Parade travels east on Yucaipa Boulevard. William Murray is in the 1928 Chevrolet and W. A. Davis, at left, drives by Dolen's Grocery and home. William Murray, at right in the 1928 Chevrolet, drives by Holsinger's.

Pictured from left to right, Alexander, Marie, and Harry Birkbeck pour fresh-pressed cider into jugs at their ranch on Sixth Street.

Dan Dolen's home and store, left, can be seen in this view looking east on Yucaipa Boulevard in the 1930s. Dolen's home was later moved to Avenue A near First Street.

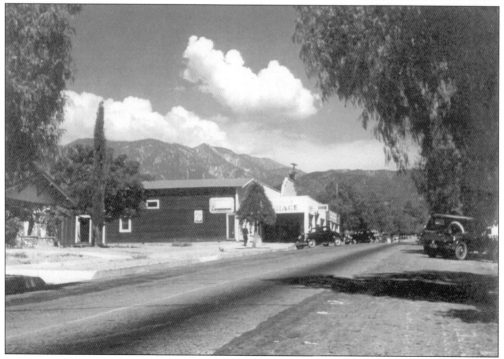

75

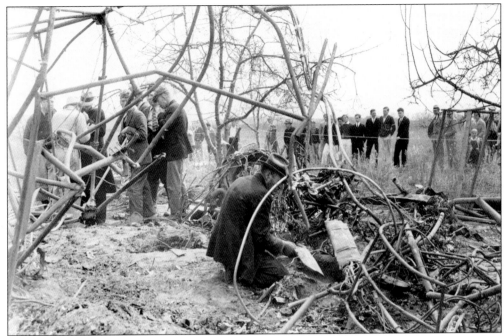

A trimotor American Airways Fokker cabin 7-10 carrying four passengers and two pilots crashed on March 19, 1932, into Alex Murray's orchard on Fifth Street at Avenue H. J. A. R. Thomas saw the plane as it circled over the apple orchard in the fog, but it hit some Edison power lines to the north and burst into flames when it landed.

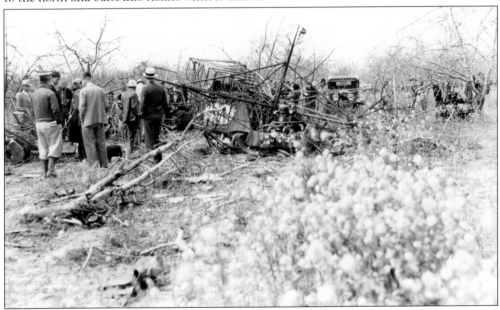

Members of the American Legion Post No. 426 took charge of the scene of the crash, serving as guards until the U.S. Postal Service arrived. On duty were E. C. Craig, E. S. King, A. L. Ford, William F. Cruickshank, W. J. Murray, Mel Wheeler, William Blair, Charles H. McCollough, Justin S. Norcross, and Harold Rouse, the local postmaster. The passengers were from Tucson, Cincinnati, and St. Louis.

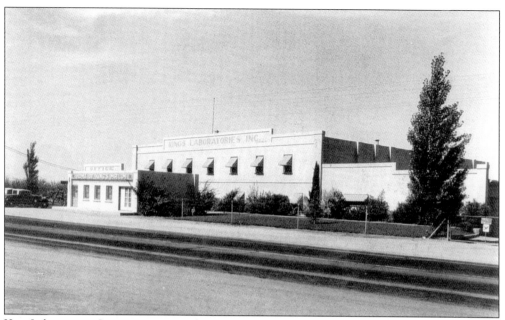

King Laboratories, Inc., was a major industry in the 1930s. Famous for its fix-all elixir, King's Maelum, the business got its fruit from many local orchards. Congressman Harry Sheppard represented the business for many years before beginning his career in government. The two-story building burned twice; the second time was because of an explosion. The facility is believed to have been involved in the transportation of moonshine, an industry that thrived in the later 1920s.

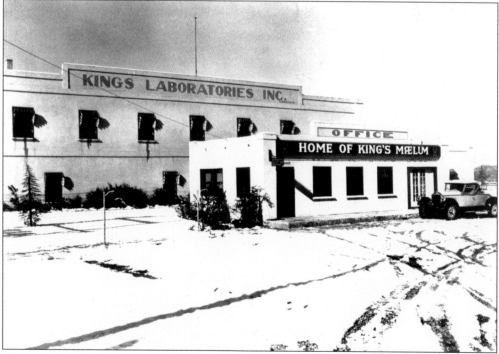

The small office building existed on Calimesa Boulevard until 2006. It had been a liquor store, shoe-repair business, and a dental office.

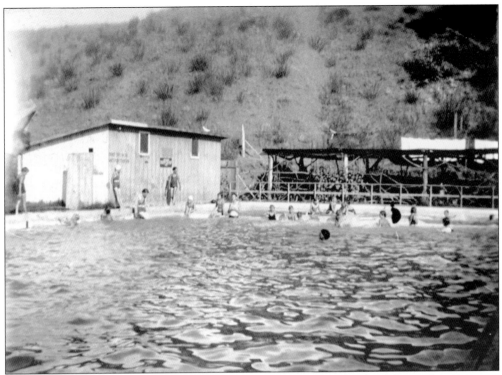
The men's locker rooms at the Wildwood Plunge were at the south side of the pool.

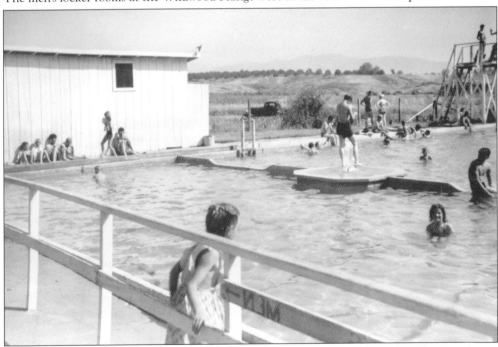
Local youth spent many happy days at the Wildwood Plunge well into the 1950s. They are shown here with orchards and a truck driving down Avenue G in the background. The Seventh Street pool was constructed in 1957.

Yucaipa swimmers, from left to right, are Marian Rehkopf, Forrest Rehkopf, and Harold Graham; they are standing in front of Larry Rehkopf in a boat in 1932 at the Wildwood Plunge.

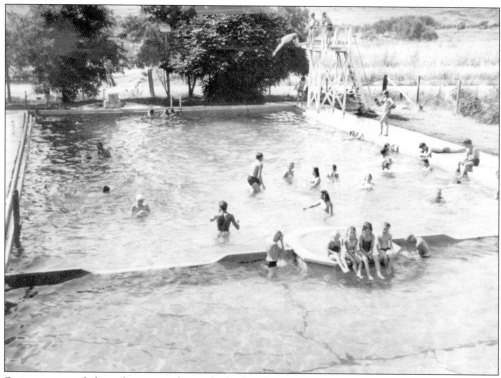

Swimming pools have been popular with the local young from the early days. The first facility, which was a converted water reservoir on Fifth Street, was prepared by the Yucaipa Chamber of Commerce in 1921. The Wildwood Plunge was opened later in the same decade on Avenue G at Highway 99.

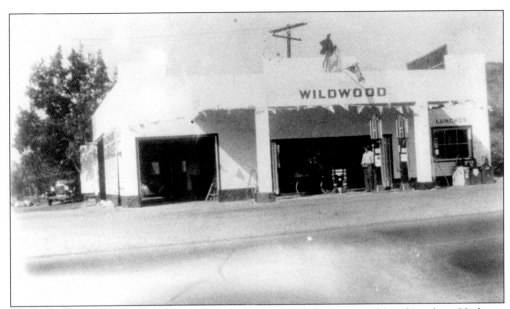

The Wildwood garage, complete with gas station and store, also served lunches along Highway 99, which is known today as Calimesa Boulevard.

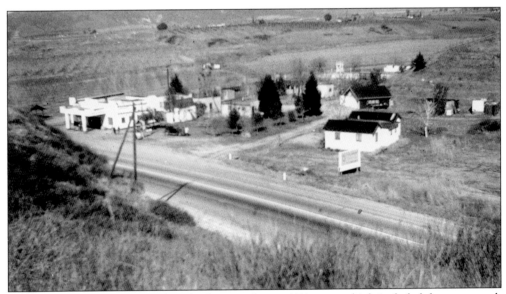

Worthy Rehkopf and Will Graham built a complex on 14½ acres, which included the store, pool, cabins, and garage.

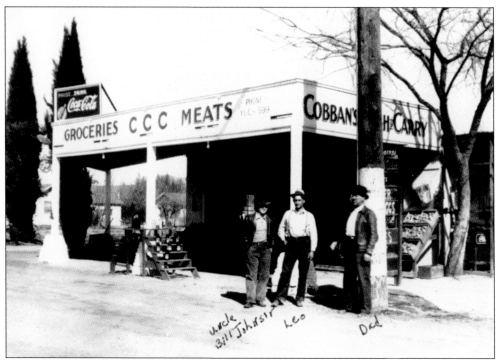

Cobban's Cash and Carry flourished in the 1930s on Dunlap Boulevard when it was known as Ocean-to-Ocean Boulevard, just up the boulevard from the Yucaipa Dairy. Bill Johnson, Leo Priebe, and Lorraine Priebe's father stand in front of the store.

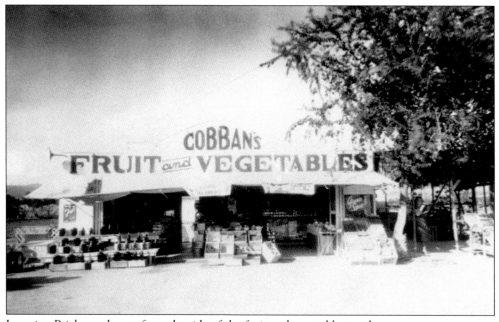

Lorraine Priebe peeks out from the side of the fruit-and-vegetable stand.

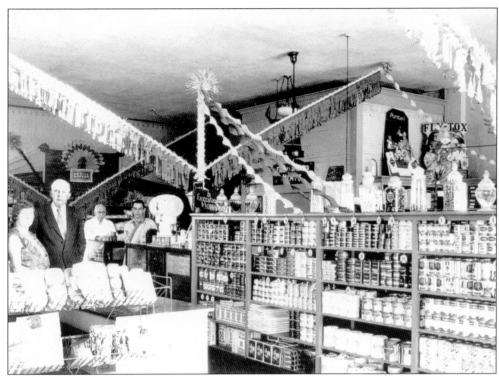

Dunham's Market was a busy grocery store during the 1930s.

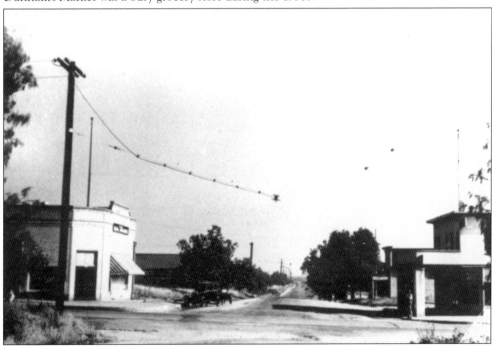

Looking south, the corner of Yucaipa Boulevard and California Street during the 1930s shows the Corner Market (Dunham's) on the left and Yucaipa Hotel on the right. The intersection sported a light.

Chester Cole and Reverend Stockton took hundreds of photographs of Yucaipa during their lifetimes. They are pictured together in Oak Glen during the 1930s.

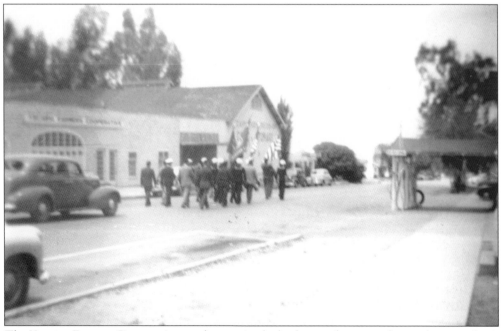

The Yucaipa Farmers Cooperative can be seen in the background as a parade marches west down Yucaipa Boulevard.

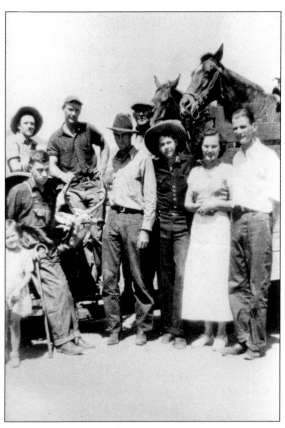

From left to right, Kent Angrimson, Lawrence Ward, Albert Jordan, Elmer Senff, Eldon Jackson, Ed Sweeters, Louwella Ward-Schermahorn, and her daughter (in front) gather during the Depression years after a hunt.

From left to right, Emma Senff, Esther Senff, Albert Jordan, and Wilamina and John Jordan stand on the porch of a cabin in Wildwood Canyon in 1932.

Elmer Senff sits with Zilch and Spud in 1933.

Esther Senff poses in 1933 in front of one of the cabins in Wildwood Canyon.

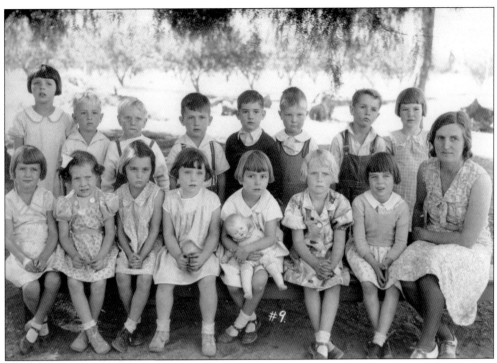

Margaret Burness sits with her 1930s-era kindergarten class at Yucaipa Grammar School.

The original Yucaipa Grammar School was replaced with a larger facility in 1927. The old school continued to be used for the lower grades.

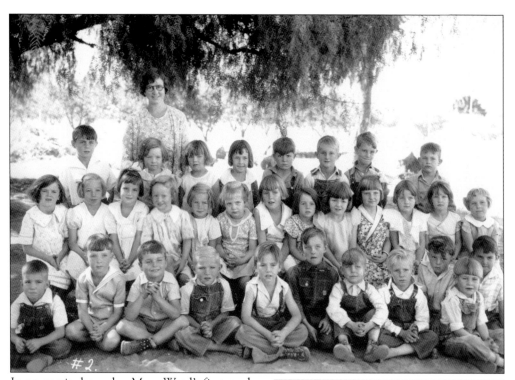

In no particular order, Mary Ward's first-grade class includes (front row) Dale Schemerhorn, Charles McCollough, Charles Beaumont, Don Vendergoot, Robert Turner, Paul Smith, Lloyd "Claude" Dike, and Billie Cox; (middle row) Ruth Norton, Floy Jean White, Marguerite Houston, Elda Mae Peeden, Roberta Stoddard, Viola Duke, Betty Jean Neal, Autumn Reed, Mildred Davenport, Fanny Jean Wagoner, Mildred Cagle, and Carla Mae Sutt; (back row) Jackie Hubbard, Lois Sutt, Randal Smith, Gilbert Johnson, and Bobbie Holsinger. Eight of the students are not identified.

Mabel Cathcart was a teacher at Yucaipa Grammar School in 1933–1934.

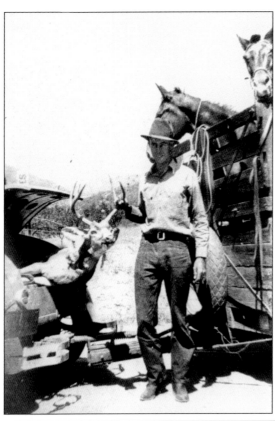

Eldon Jackson shows off a deer he bagged north of the Wildwood Lodge in 1933.

The Yucaipa Cooperative Exchange was important to the community during the Depression, as local residents would trade food and necessary items because funds were in short supply. Some residents got through the rough times by working for the Work Projects Administration.

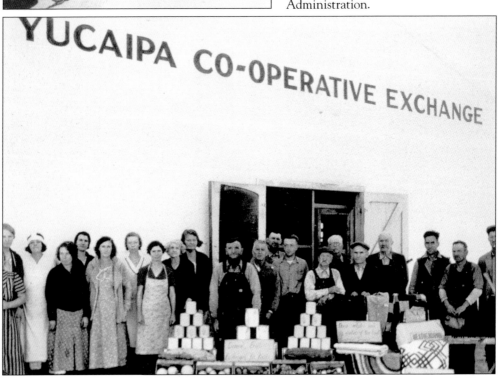

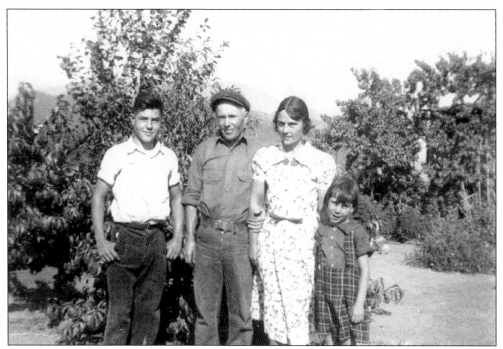

David, Ben, Ruth, and Gladys Stirdivant stand in their peach orchard along Wildwood Canyon Road when it was called Avenue F. The Stirdivant orchards thrived for 55 years. The family produced peaches, plums, and tomatoes and trucked them to three areas of Los Angeles.

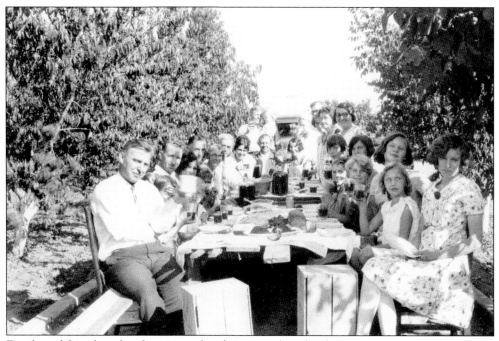

Family and friends gather for a picnic lunch in a peach orchard.

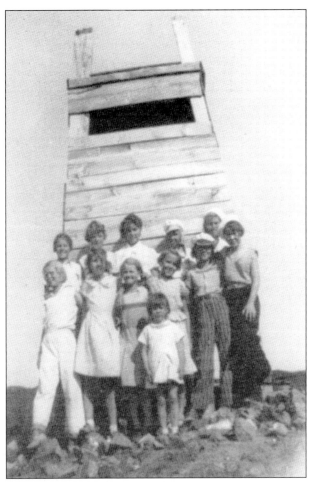

The signal tower on Signal Hill (also known as Y Hill) was built in 1934 at the east end of Avenue D and used by the Boy Scouts sponsored by the United Methodist Church to teach semaphore signals and Morse code. The tower was later used during World War II as an aircraft-identification tower. For many years the Scouts cut a "Y" in the vegetation on the hill.

Peach packers pose together in June 1936 at the Seeley packinghouse on Avenue D between Tenth and Eleventh Streets on the north side of the street. They were packing Florence peaches.

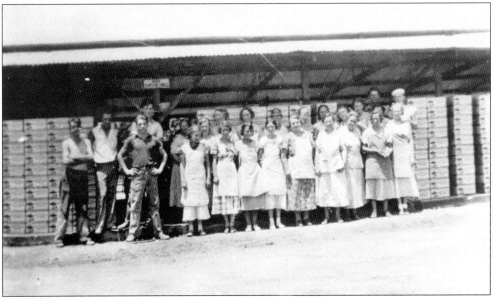

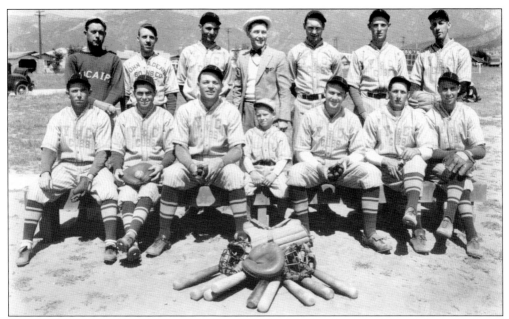

The Yucaipa-Calimesa Cubs were managed during the 1934–1935 season by Congressman Harry Sheppard (back row, center). The team played throughout the 1930s and was very successful.

Lincoln Park on Oak Glen Road was the site of many picnics. The site later became the Yucaipa Airport and has since been replaced by the Chapman Heights development.

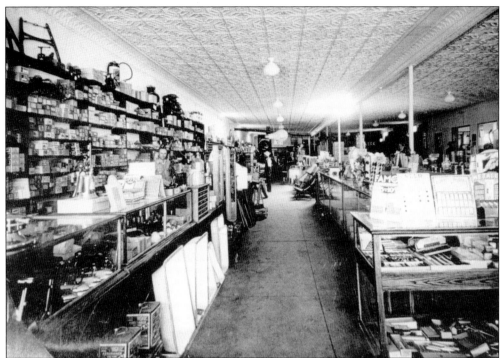

Holsinger Hardware Store, formally known as Yucaipa Lumber and Supply Company, was owned by J. W. Cruickshank. He operated the hardware store and his son W. F. Cruickshank ran the lumberyard. D. M. Holsinger bought the business and ran it for many years with the help of Gordon Greenslade, Elwin G. Hale, and Harvey Brown. The building west of the hardware store was a garage owned and operated by W. T. Little. Butch Renshaw worked for Little as a mechanic. The buildings were attached when Holsinger added a furniture store. The photographs were taken in 1935.

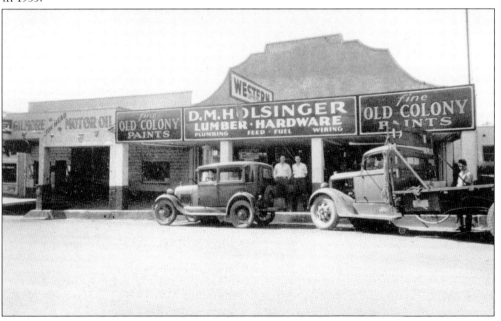

The first plans for fire protection were discussed in March 1929 at the chamber of commerce meeting by its president, William Mitchell. They called for the formation of a tax district for fire protection in cooperation with the County Forestry Department. In March 1931, a new state fire truck arrived and was stationed at the Ed Guthrie residence on South Yucaipa Avenue. Records indicate Guthrie was the county district fire warden and state forestry ranger as early as 1930. In January 1936, work started on the concrete foundations for the group of buildings that would become Yucaipa's first fire station located on Avenue A east of Yucaipa Avenue, which is today's California Street.

Trees, bushes, and a lawn decorated Yucaipa's first fire station after its first few years in operation.

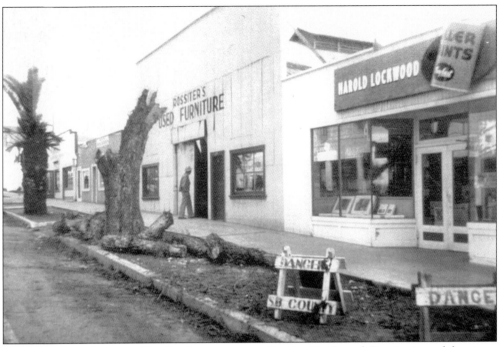

Harold Lockwood operated his hardware store on Yucaipa Boulevard. Rossiter's used furniture store was next door.

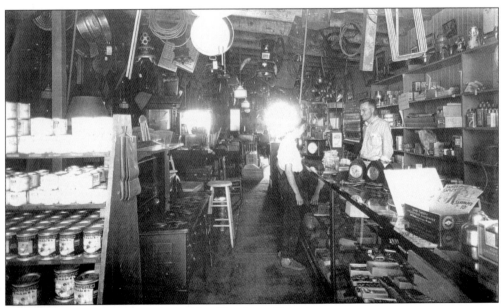

This 1936 photograph shows the inside of Lockwood's business.

W. A. Davis Market became the location of the first Stater Brothers market in August 1936. Here Davis carries groceries to a car for a shopper just prior to the sale to the Staters.

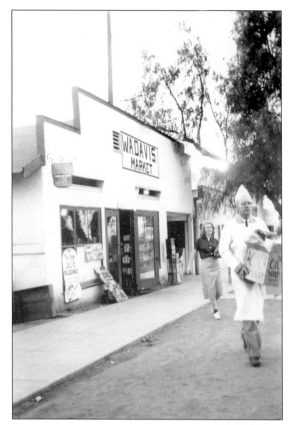

The interior of the first Stater Brothers market shows the wide array of groceries. The store was located on the south side of Yucaipa Boulevard between California and First Streets.

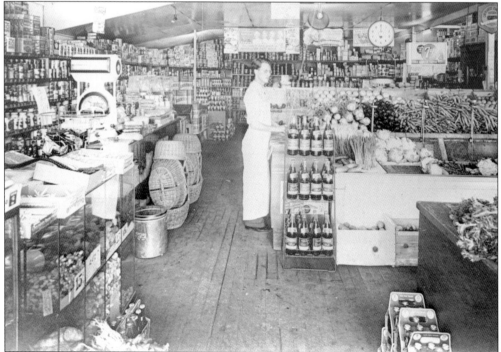

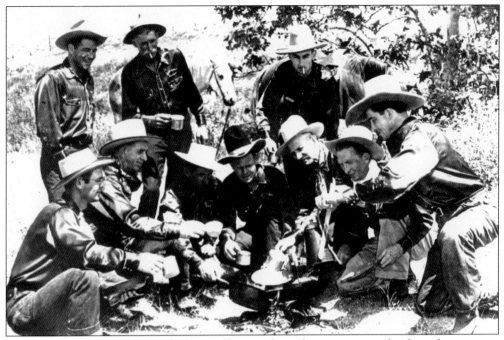

A group of local men gather with their coffee cups for a planning session for the rodeo.

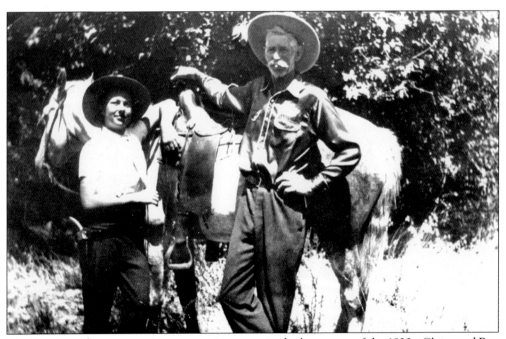

The Yucaipa rodeos were major community events in the later years of the 1930s. Claire and Ray Webster pause by their horses in 1939. Both participated in the events.

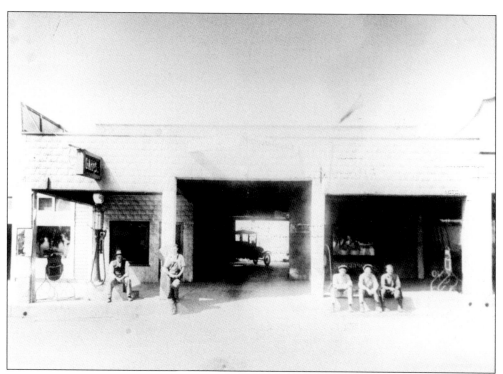

This photograph of the Michigan Garage, located west of Holsinger Hardware, shows Butch Renshaw and W. T. Little (left) in 1939.

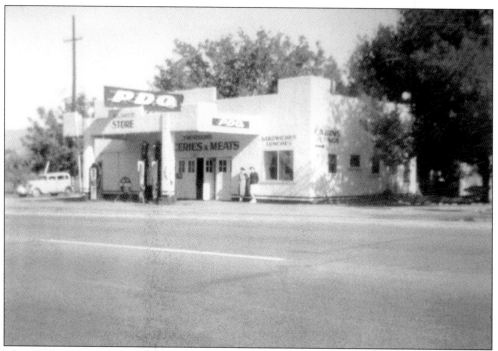

The Wildwood Station had become a PDQ and Thorson's Grocery store by 1939. It was located at Highway 99 and Avenue G.

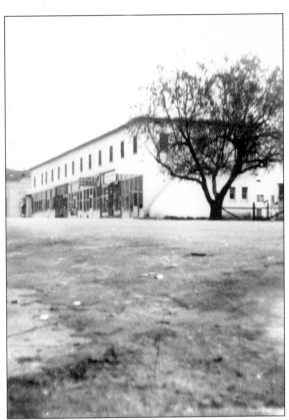

The Yucaipa Water Company, a clothing store, a barbershop, and the drugstore operated businesses in the Yucaipa Hotel building about 1939.

Mary Parks serves Robert King and his sons in the drugstore in the Yucaipa Hotel building on Yucaipa Boulevard at California Street about 1938.

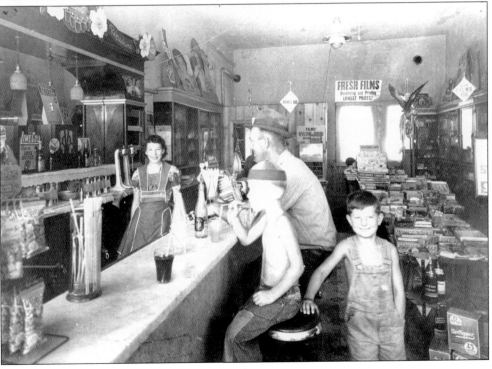

Six

THE 1940S
SURVIVING AND THRIVING

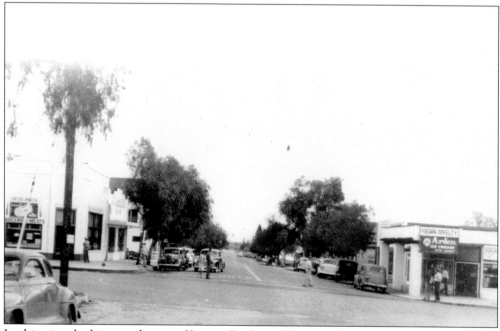

In this view, looking south across Yucaipa Boulevard down California Street, Dunham's store is on the left and the old hotel building no longer boasts a top floor. California Street has been paved, and business thrives in Yucaipa's uptown.

Chuck Benefiel glances back as he stands next to Will Rogers's horse, which is grazing at Casa Blanca in 1940.

The back-to-school parade shows community pride and also provides free shows at the local theatre.

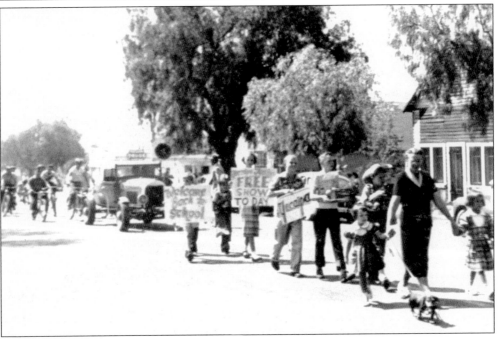

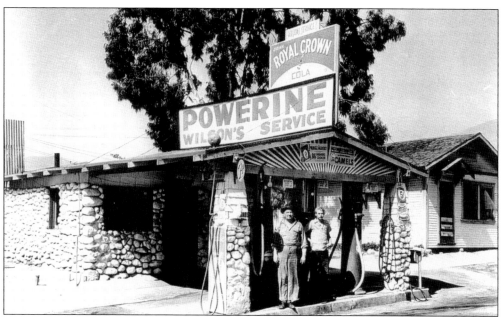

Milton "Pop" Wilson, left, and Pete Smith stand in front of Wilson's Service in 1940 at 34974 Yucaipa Boulevard. The building to the right still exists.

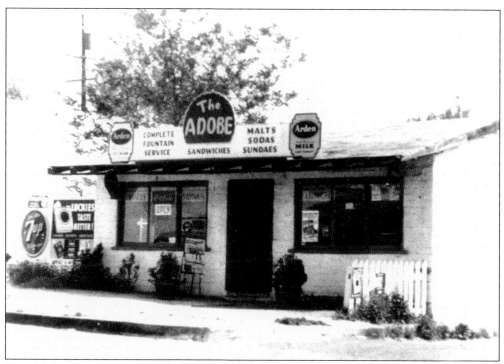

The Adobe Café was operated by Pete and Hadley Burklow at 35131 Yucaipa Boulevard.

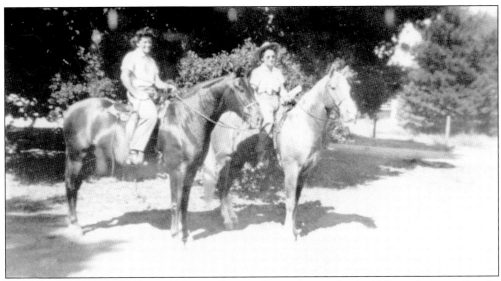

Marge Bomgardner on Vicky and Marian Hunt on Paco ride together in 1941 on the Hunt Ranch. They rode together for years on the land that is today Yucaipa's Wildwood Canyon State Park.

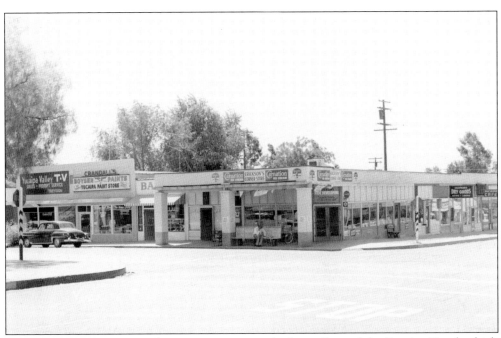

In the 1940s, commerce was booming uptown on the lower floor of the Yucaipa Hotel, which contained a bakery, paint store, Erickson's corner store, dry goods, and more.

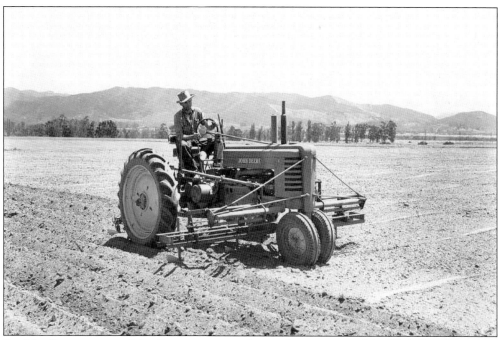

Ray Vandiver operates a John Deere tractor on the northwest corner of the Clyde Ranch in 1944. A portion of the ranch is today's Yucaipa Regional Park.

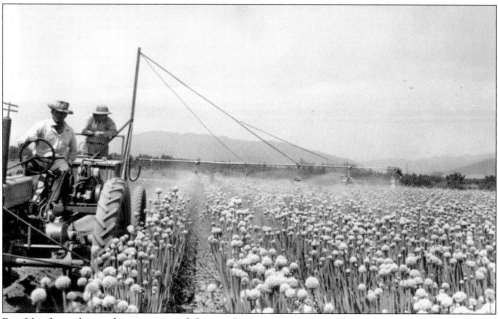

Ray Vandiver drives the tractor, and George Bomgartner sprays Glenn Bomgartner's onion-seed crop at California Street and Avenue F c. 1947.

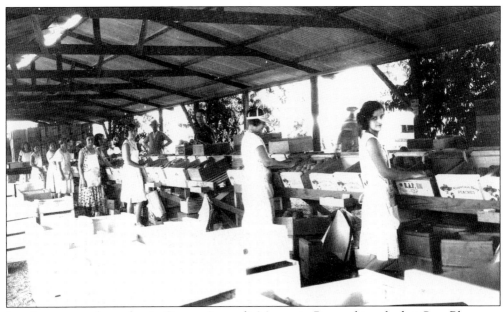

Local women pack peaches in George Atwood's Mountain Boy packing shed at Casa Blanca.

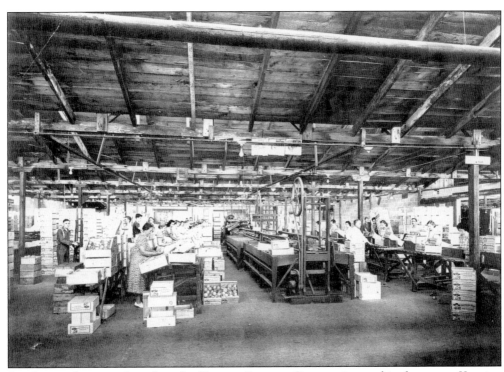

Peaches are being packaged in the Yucaipa Farmers Cooperative packinghouse on Yucaipa Boulevard about 1940. The Mountain Boy brand is evident.

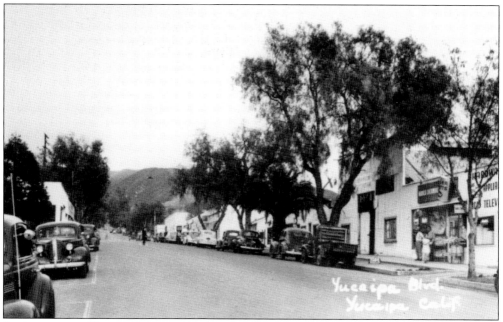

Looking east up Yucaipa Boulevard in the 1940s, Harold Lockwood's store is on the right. Along the street are Mallet's Feed, Ellis Barbershop, Davis Market, and the Bartlett home. Holsinger Lumber is on the left with the portico extending to the curb. The entrance of Dunham's store can be seen in the distance on the right.

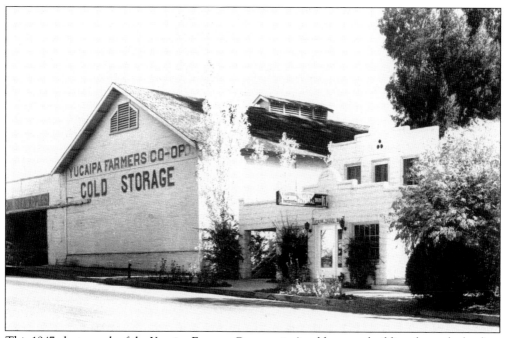

This 1947 photograph of the Yucaipa Farmers Cooperative's cold-storage building shows the loading dock for Oak Glen apples on the left and the Yucaipa Valley National Bank on the right.

Orville "Speed" Matzkie stands next to the garage of the Yucaipa Fire Station in 1942. The Yucaipa Hotel can be seen in the background.

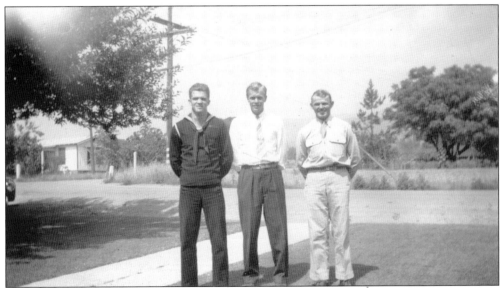

Dale Scarbrough, Roy Davis, and Harry Birkbeck gather during World War II. They all served in the U.S. Armed Forces; Dale in the navy, roy in the army, and Harry in the army air corps.

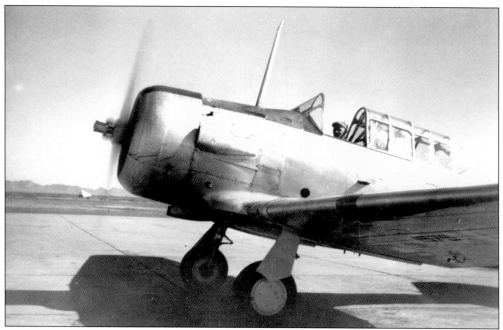

Harry Birkbeck does a preflight on a AT-6 plane during World War II at Dateland, Arizona. These planes were used for a refresher course in gunnery by fighter pilots before returning to duty after "R and R." Many of these pilots were aces with five or more planes shot down. For a list of local residents who served their country in World War II, see page 127.

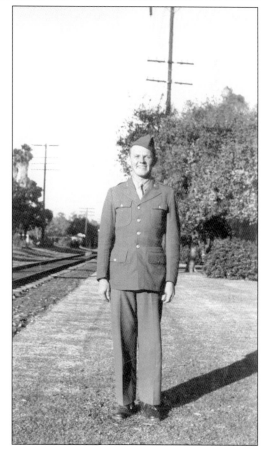

Harry Birkbeck is pictured here during World War II.

Fire captain Ed Guthrie, left, leans on a car in front of the Yucaipa Fire Station garage.

This picture of the Yucaipa Fire Station in 1942 shows the screened-in porch, which would later be enclosed. Also, the kitchen later would be enlarged.

Gerri Toner Smith and Judy Locke stand next to the Yucaipa Valley Riding Club truck.

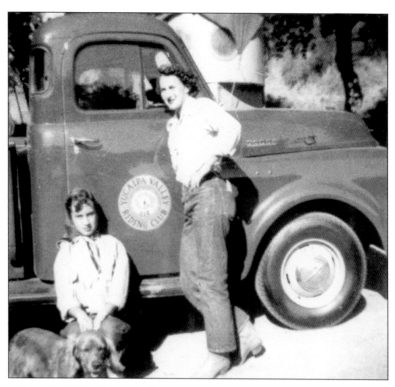

Marge Vandiver drives a buggy past the booths and around the arena in the 1947 Peach Festival at Avenue A and Second Street.

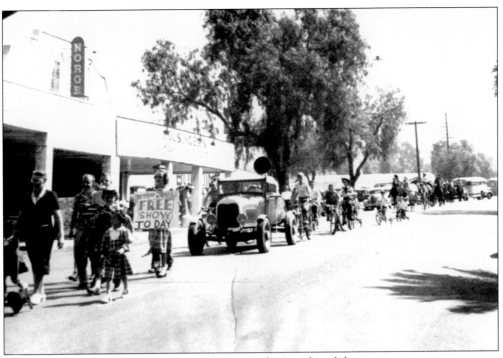

Yucaipa loves a parade, from the little tykes on "trikes" to the adults.

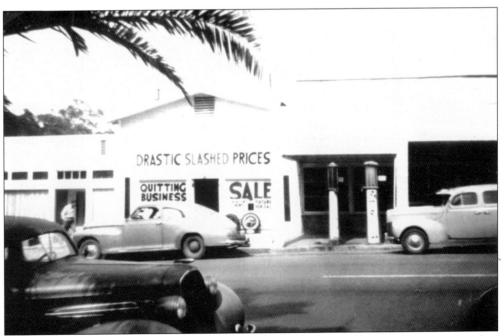

While Holsinger Hardware continued in business into the 1980s, the furniture store closed in 1948. The gas pumps can be clearly seen at the garage.

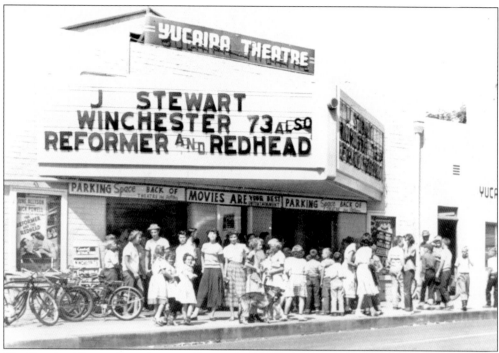

The Yucaipa Theatre brought joy to Yucaipa's youth in the 1940s. The theatre was operated by Red Miller at the California Street facility, which is now a group of storefronts.

It would be later in the decade that a seven-minute newsreel called "Woman Speaks" would be shown in the Yucaipa Theatre. It featured Yucaipan Nan Songer and her daughter Betty, along with five other women, including Amelia Earhart.

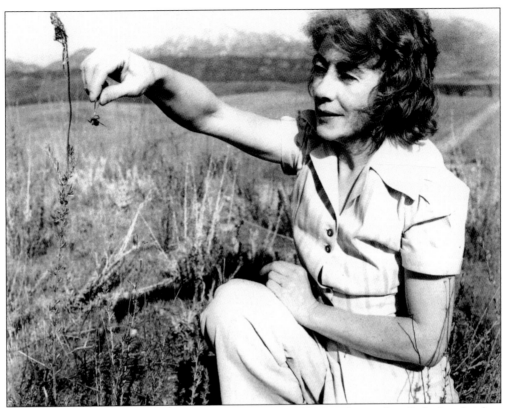

Nan Songer did her part to win World War II, producing black-widow spider silk for bombsights.
The Songer spider farm became a classified operation during the war, and a sophisticated delivery
system of couriers traveling in top secret through Canada delivered the goods to the factory.

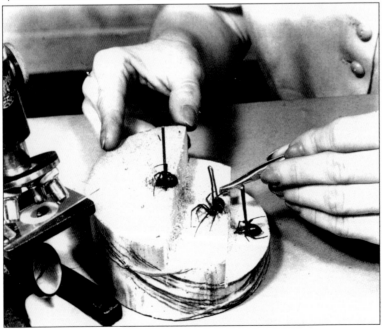

Songer milks three
black widows for
their silk in her
laboratory off
Juniper Street
in Yucaipa.

The Yucaipa Post Office was located at 35139 Yucaipa Boulevard. Postmaster Harold Rouse is pictured here in 1947 at the far right.

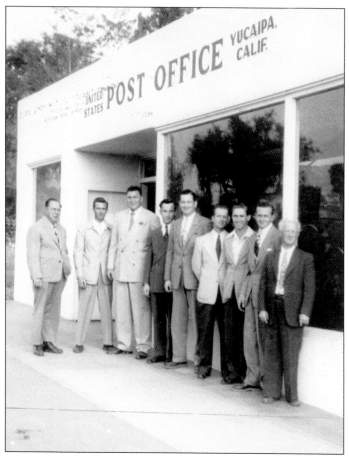

During the 1940s, Yucaipa rabbit farms produced meat for restaurants in Los Angeles. Flora McNaire stands in the snow at her rabbitry in 1948.

Students from Mrs. Fugate's second-grade class in 1933–1944 at Yucaipa Grammar School are seated at and standing on a picnic table. Ben Fugate, the school principal, is in the center of the back row.

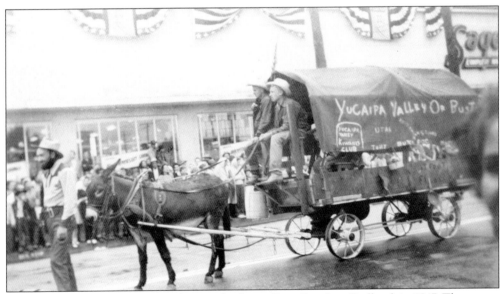

George Bomgartner and his mule drive in the Surrey Days Parade in Redlands in 1947. The wagon sports the saying "Yucaipa Valley or Bust."

Pictured here, from left to right, is the Stater family—Cleo, Virgil, Mary (mother), Lavoy and Leo Stater—as Stater Brothers Market returns to Yucaipa in 1948 after the closing of the first store in 1937. The second market was on California Street south of Avenue A.

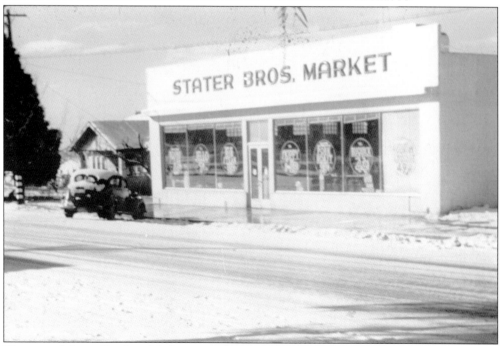

The second Stater Brothers Market opened in November 1948.

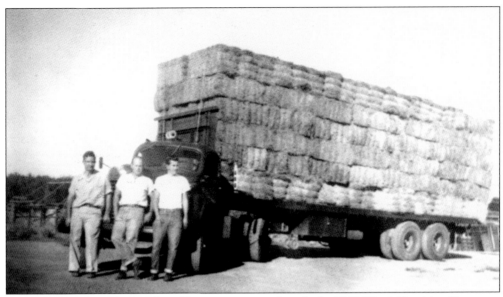

Many farms and ranches produced large quantities of goods. In 1949, King's Trucking Company was kept busy. Pictured from left to right are Elmer May, Tommy McArthur, and Bob King.

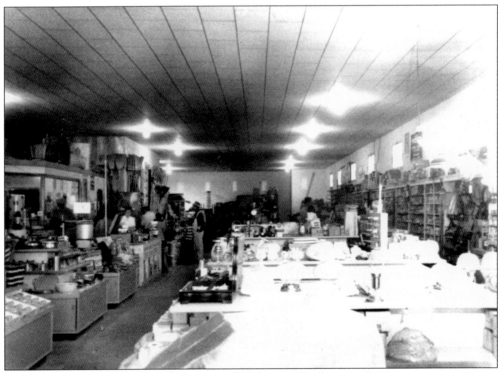

Elwin Hale and Gordon Greenslade operated Holsinger Hardware in 1948.

Seven

THE 1950s
LET THE GOOD TIMES ROLL

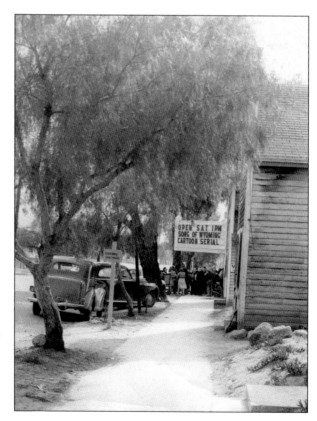

California Street was lined with pepper trees, which provided shade to local businesses. The Yucaipa News-Mirror Building is on the right. Down the block, a large crowd waits for the opening of the Yucaipa Theatre.

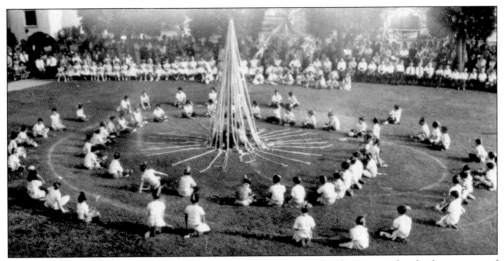

May Day celebrations were still a big occasion in the 1950s. Students wait for the beginning of the 1950 maypole dance held in front of the Yucaipa Elementary School.

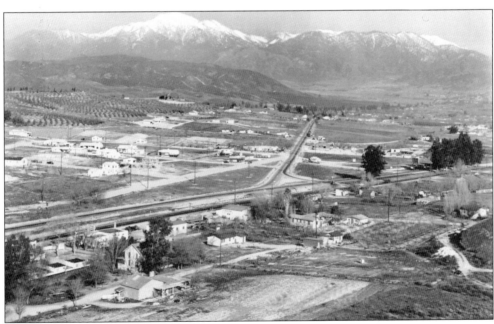

From one end to the other, Yucaipa Boulevard exhibits new housing along with agricultural uses. In this 1952 view, Highway 99 and the boulevard join at a simple triangle.

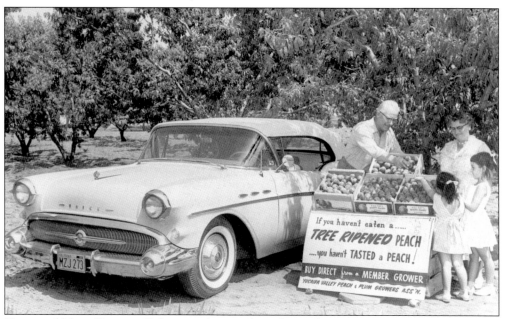

Harry and Marie Demin sell their peach crop along the road.

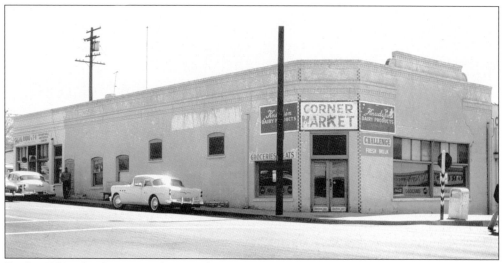

By the 1950s, the Corner Market was showing wear and was soon to be renovated.

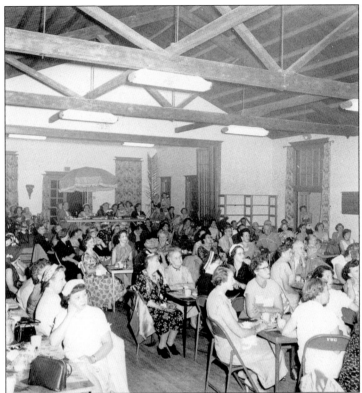

The members of the Yucaipa Woman's Club continue to be a force in the community. The clubhouse is often full at the regular meetings and special events. The clubhouse functions as a community center, dance hall, party place, and meeting facility.

The Woman's Club was involved in saving the Yucaipa Adobe, in providing social services, and in the planting of the local parks. They provided the first picnic tables at Seventh Street Park. Edith Sherer and DeLos Wilbur pause at the first table while the first shade trees—camphor, fruitless mulberry, blossoming crab, black locust, and California live oak—are planted.

In 1950, John Jordan, Emma Senff, and Henry Senff look west from Flag Hill, another important park in the community.

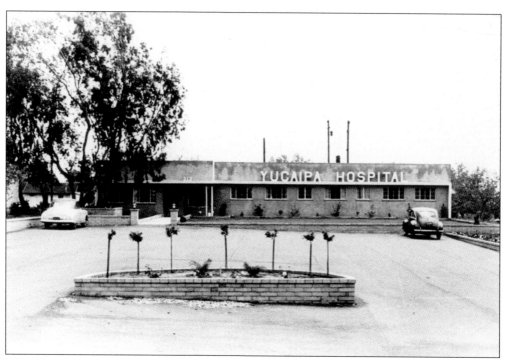

Many Yucaipans were born in the Yucaipa Hospital, which was at Yucaipa Boulevard and Third Street. Dr. Alton Edwards ran the hospital from 1951 to 1972.

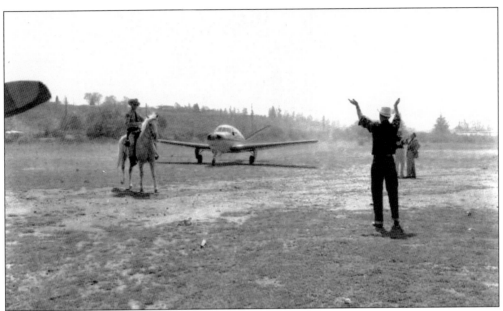

Horses and airplanes mix nicely at the Yucaipa Airport, which included a hangar and grassy landing field.

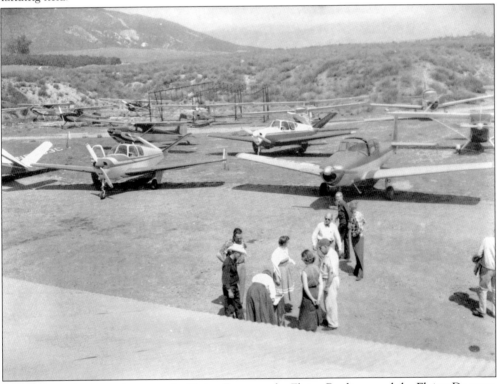

The Yucaipa Airport is home to the Flying Farmers, the Flying Realtors, and the Flying Doctors. It operated during the 1940s into the early 1960s and was adjacent to Lincoln Park. Both the airport and the park gave way for the Chapman Heights development along Oak Glen Road west of the Yucaipa Regional Park.

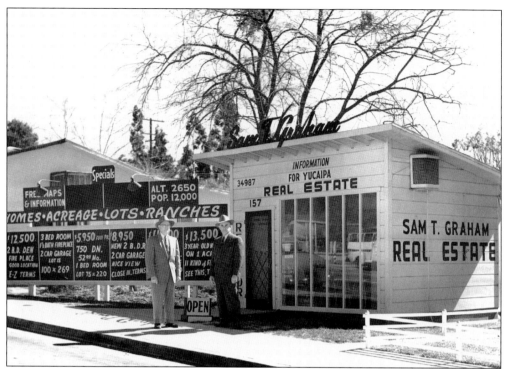

In 1955, after the change of street names and house numbers, some businesses kept both addresses on their buildings, such as Sam Graham's real estate office on upper Yucaipa Boulevard. Graham's office is west of First Street on the south side.

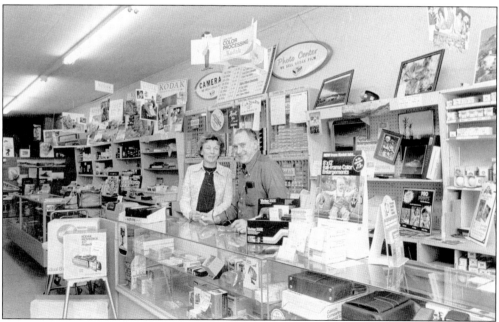

Jean and Don Burian ran Burian's Photo Center at 35139 Yucaipa Boulevard. Don took hundreds of photographs of the community over the years.

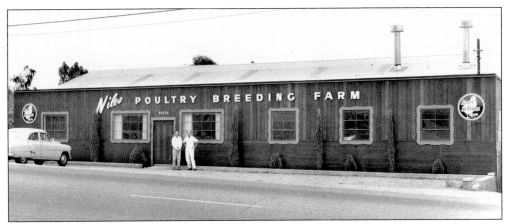

The egg industry gave Yucaipa the "Egg Basket of Southern California" moniker during the 1950s. Local egg production continues but is no longer located near the town site. Niles Poultry was on Yucaipa Boulevard at the overpass.

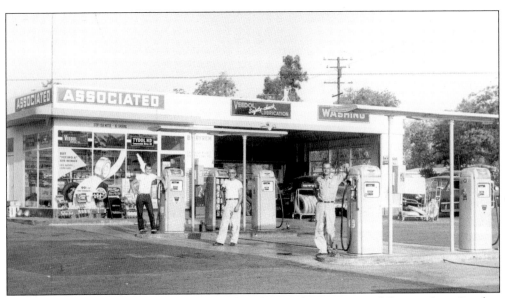

Bryem's Associated Gas station was located at the northeast corner of County Line Road at Calimesa Boulevard.

On September 15, 1956, the first substation opened at 35077 Yucaipa Boulevard. Chuck Follett, left, and Gene Prince stand in front of the office.

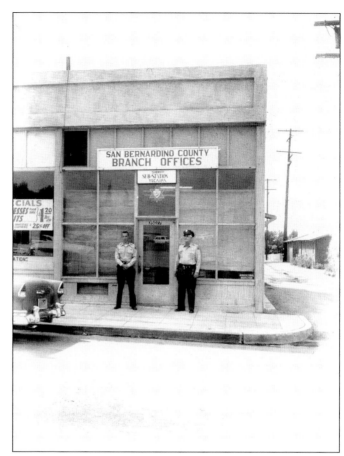

Stater Brothers Market opened a bigger, better store at 34601 Yucaipa Boulevard on March 20, 1959.

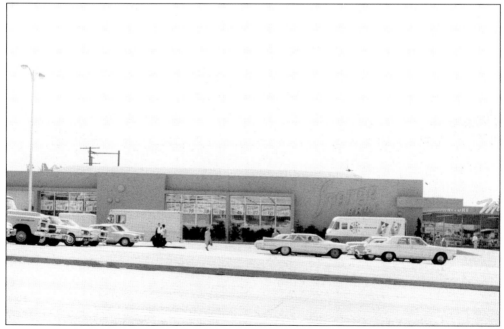

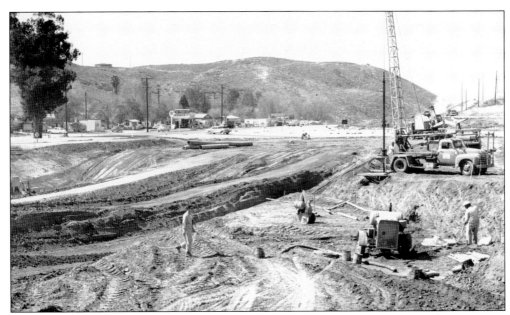

Major excavations will provide for east and west lanes of Highway 99 to go under a Yucaipa Boulevard turnoff. It would be the next decade before Interstate 10 would be constructed. Gas stations, a furniture business, and cabins are left on the west side of the road.

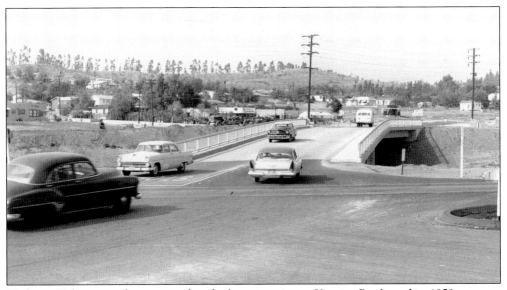

Highway 99 became a frontage road at the busy junction at Yucaipa Boulevard in 1959.